J. M. Nash

CUBISM, FUTURISM
AND CONSTRUCTIVISM

D0910785

BARRON'S
Woodbury, New York

First U.S. Edition 1978
Barron's Educational Series, Inc.

Text filmset by Keyspools Ltd, Warrington, Lancs.
Litho origination by Paramount Litho Ltd, Wickford, Essex
Printed in Great Britain by Cox and Wyman Ltd,
London, Fakenham and Reading

Library of Congress Catalog Card No. 77–76770
International Standard Book No. 0–8120–0881–2

Printed in Great Britain

Cubism, Futurism and Constructivism were the three most important movements in early twentieth-century art. They developed in different places and at different times – Cubism grew up in Paris between 1907 and 1914, Futurism was announced in a manifesto from Milan on 20 February 1909, and Constructivism first flourished in Moscow after the Revolution of 1917 – but there were many links between them. The Futurist painters visited the studios of the Cubists in Paris in 1911 and what they saw there profoundly influenced their style. The Constructivists learned from both earlier movements. Almost all the major artists of the first half of this century were active in one or more of the movements. Between them they created modern art. They created new forms, experimented with new procedures and propounded theories of art that still affect our ideas about the purpose and value of art. But in many ways the movements were strongly opposed to each other. It was not simply that the Cubists dismissed the Futurists as Italian plagiarists – as they did – or that the Italians called Cubism a 'sort of masked academicism' and said their own art was the only truly modern, *dynamic* art, or that, later, the Constructivists wrote that the 'attempts of the Cubists and Futurists to lift the visual arts from the bogs of the past have led only to new delusions'. No doubt much of this abuse sprang from the modern need to appear to be totally original. But it is clear that despite their various similarities, and despite their mutual interest in and indebtedness to each other, the three movements did stand for quite different values, and these values were moral and social as much as aesthetic.

Cubism

Modern art, it has often been said, began with Cubism. Cubism has been called a revolution in the visual arts as great as that which took place in the early Renaissance. Futurism and Constructivism owed it a debt that they disliked having to acknowledge. But unlike Futurism and Constructivism, true Cubism was not conceived as a movement at all. Whatever its other virtues, a movement in art, like a political movement, sets out to confront the larger public. It depends on organized demonstrations for its existence. True Cubism was, on the contrary, a deliberately private, essentially esoteric art, created by two painters for themselves and for a small circle of intimates.

These painters were Pablo Picasso, who was Spanish, and Georges Braque, who was French. Their circle of friends included a number of avant-garde writers, Max Jacob, Guillaume Apollinaire, André Salmon, and the wealthy American Gertrude Stein. The only other painter within the circle was André Derain. Most of these friends lived in Montmartre, the village on the hill overlooking Paris that in the late nineteenth century had become the centre of Parisian nightlife. The ramshackle slum where Picasso and Max Jacob lived had earlier housed artists and writers of Gauguin's generation and had been visited by Gauguin himself. The group self-consciously inhabited Bohemia, the world of art. To the larger world it was indifferent: art, as the neglected careers of Cézanne, Gauguin and Van Gogh had proved, was necessarily incomprehensible to the majority. In their memoirs the writers recalled their poverty with affection: 'We all lived badly. The wonderful thing was to live at all,' wrote Max Jacob. The writers took jobs or wrote journalism. One or two discerning picture dealers visited the artists' studios and bought their works. But the group could survive largely because one of its members was also wealthy. Gertrude

Stein probably bought more of Picasso's works produced before 1906 even than Ambroise Vollard the dealer.

It was a small circle that gloried in its exclusiveness. 'We invented an artificial world with countless jokes and rites and expressions that were quite unintelligible to others,' wrote André Salmon later. Max Jacob called the studios in which he and Picasso lived the Bateau Lavoir, the floating laundry, presumably because it was on a hillside and was filthy. At the centre of the circle was Picasso. The friends visited his studio almost daily; its doorway was inscribed *au rendez-vous des poètes*. The group as they visited the bars and cafés of Montmartre were known as *la bande à Picasso,* the Picasso gang.

Gertrude Stein described them: 'They began to spend their days up there and they all always ate together at a little restaurant opposite, and Picasso was more than ever . . . the little bullfighter followed by his squadron of four . . . Napoleon followed by his four enormous grenadiers. Derain and Braque were great big men, so was Guillaume [Apollinaire] a heavy set man and Salmon was not small. Picasso was every inch a chief.'

For his friends Picasso was unique: a compelling, unpredictable, enigmatic genius. He had been an infant prodigy in Barcelona and had had his first exhibition in Paris when he was only nineteen, in 1901, at the Vollard gallery. Apollinaire described him as he was at twenty-four: 'an adolescent with restless eyes whose face recalled at once those of Raphael or Forain. . . . His blue workman's overalls, his sometimes cruel jokes, and the strangeness of his art were known all over Montmartre. His studio, cluttered with paintings of mystical harlequins, with drawings that people walked on and that anyone could take home if he wished, was the meeting-place of all the young artists, all the young poets.' In 1911 Picasso's friend André Salmon gave his version of

Picasso receiving visitors to his studio. 'Welcoming and quizzical, dressed like an aviator, indifferent to praise as he is to criticism, at length Picasso shows the much sought-after canvases he has the coquetry not to exhibit at any salon.'

Salmon's account – and Apollinaire's – emphasize Picasso's idiosyncrasies, his manner, his blue denim uniform, his total indifference to public recognition. But they are, it must be recognized, carefully promoting Picasso's image. These descriptions were pieces of journalism written to establish Picasso's originality when other lesser artists were beginning to attract attention with their versions of Cubism. 'There has been some talk about a bizarre manifestation of Cubism, . . .' wrote Apollinaire in 1910; 'it is simply a listless and servile imitation of certain works that were not included in the Salon and that were painted by an artist who is endowed with a strong personality and who, furthermore, has revealed his secrets to no one. The name of this great artist is Pablo Picasso.'

Because the ones who ought to know, Apollinaire, Salmon and Gertrude Stein, ignored or belittled Braque's role in the genesis of Cubism, he was believed to have been one among a number of Picasso's followers. Apollinaire, who was a good friend of André Derain, in an article in *Le Temps* in 1912, first proposed that Derain and Picasso had created Cubism together. Apollinaire preferred to call Braque 'the verifier': 'He has verified all the innovations of modern art.' It was only in 1917, after he and Braque had suffered similar wounds in the War, while Picasso sat in Paris and jeered, that Apollinaire wrote to the papers to assert Braque's equal contribution and to insist that Cubism was not Spanish, but Franco-Spanish or, more simply, Latin.

Despite this belated attempt to make amends to Braque, the accepted version of the relationship was repeated much later by Gertrude Stein. In Gertrude Stein's *The Autobiography of Alice B. Toklas*, 'Miss

Toklas' recalls seeing two paintings at the Salon des Indépendants 'that looked quite alike but not altogether alike. One is a Braque and one is a Derain, explained Gertrude Stein. They were strange pictures of strangely formed rather wooden blocked figures.'

Later, Gertrude Stein took Alice B. Toklas to Picasso's studio in the Bateau Lavoir. After they had left, 'What did you think of what you saw, asked Miss Stein. Well I did see something. Sure you did, she said, but did you see what it had to do with those two pictures you sat in front of so long. . . . Only that Picassos were rather awful and the others were not. Sure, she said, as Pablo once remarked, when you make a thing, it is so complicated making it that it is bound to be ugly, but those that do it after you they don't have to worry about making it and they can make it pretty, and so everybody can like it when the others make it.'

Among the awful pictures Alice B. Toklas and Gertrude Stein saw in Picasso's studio must have been the now famous *Demoiselles d'Avignon*. This great canvas filled by five enormous naked and half-naked women is now widely recognized as the beginning of Cubism. Various explanations for its ugliness have been put forward. Most of these explanations echo that given by Gertrude Stein: it is ugly because it is new. John Berger is one writer who has recognized the inadequacy of this approach. In *The Success and Failure of Picasso* he wrote: 'Blunted by the insolence of so much recent art, we probably tend to under-estimate the brutality of the *Demoiselles d'Avignon* . . . it was meant to shock. . . . The dislocations in this picture are the result of aggression not aesthetics: it is the nearest you can get in a painting to an outrage.'

This was what André Salmon hinted at when he wrote his 'Anecdotal History of Cubism' in 1912. He must have been there when Picasso first revealed the *Demoiselles* to a group of friends. 'Nudes came into being, whose deformation caused little surprise – we

7

had been prepared for it by Picasso himself, by Matisse, Derain, Braque . . . and even earlier by Cézanne and Gauguin. It was the ugliness of the faces that froze with horror the half-converted.' The Medusa-masks, he says, shocked because they affronted the Renaissance canons of female beauty.

But Salmon does not explain why Picasso should make this attack. On the contrary, he stresses the gratuity of the act. 'Picasso', he says, 'at that time was leading a wonderful life. Never had the blossoming of his free genius been so radiant . . . truly himself, sure of himself, he consented to be led by an imagination quivering with excitement. . . . He had no ground for hoping that some different effort would bring him more praise or make his fortune sooner, for his canvases were beginning to be competed for. And yet Picasso felt uneasy. He turned his pictures to the wall and threw down his brushes. Through long days – and nights as well – he drew.'

The reason for Picasso's unease can only be guessed at. A possible source can be discovered within that small circle of friends that revolved round him. The circle was all-important: not only was it the sole source of outside acclaim that he could value, but without two of its members, Gertrude Stein and her brother Leo, he might starve again as he had before they had discovered him. He was, however, not the Steins' only protegé. In his copy of the catalogue of the Salon des Indépendants held in March 1906, Apollinaire scribbled: 'at the moment [Leo] Stein swears only by two painters, Matisse and Picasso.'

Henri Matisse was thirty-six in 1906, twelve years older than Picasso and the doyen of the avant-garde. The previous year his paintings had been displayed at the Salon d'Automne with those of several friends and they had caused a sensation. Their colouring was improbably bright, daubed straight from the tube in strokes a child could have made, in the view of most critics and visitors to the exhibition. A critic,

Louis Vauxcelles, dubbed the group 'Les Fauves', the wild beasts. As the other painters in the group, André Derain, Maurice de Vlaminck, Alfred Marquet, and Kees van Dongen among them, were all younger than Matisse, he was called 'the king of beasts'.

Picasso was a regular visitor at the apartment at 27 rue de Fleurus where his new patrons lived; and each Saturday, when he went to dinner, he would see these advanced and admired paintings and often would meet Matisse himself. When, later in 1906, he began making studies for a large and unconventional painting of female nudes, he must have realized it would be at once compared with Matisse's works, and with two canvases in particular: *The Happiness of Living (Le Bonheur de vivre)*, owned by the Steins, and the *Luxury, Calm and Delight (Luxe, calme et volupté)* that had been the centrepiece of the Salon d'Automne of 1905. The latter, painted in the Pointillist technique, with prismatically bright spots of colour, represented a group of naked and half-naked women bathing and picnicking on the seashore. The *Bonheur de vivre* was even more outrageously bold. In colour and general effect it was more like a Persian carpet than a traditional European oil painting. Its drawing was as free as its colouring and suggested eighteenth-century Japanese woodcuts.

In these two ambitious paintings, Matisse had undertaken the strangest subject of nineteenth-century painting: the grand composition of female nudes. In Paris, in the nineteenth century, in the great exhibition halls of the annual Salons, to which bourgeois families flocked in thousands each weekend, the nude composition flourished in an astounding way. Venus, Galatea, Diana, minor inhabitants of Olympus, nymphs, and many other subjects were given as titles, but it was clear that the subject was becoming less and less important. But when it was stripped even of its subject matter, the nakedness of the nude composition became more problematic. If

9

Pablo Picasso. Study for the Cleveland *Harem Scene,* 1905.
Conté crayon, $22\frac{3}{4} \times 18\frac{1}{8}$ (57.5 × 46).

the critic's general impression was that it was
'acccptable', it was praised for its execution, the
excellence of its draughtsmanship, the delicacy of its
colouring, and also for the beauty of its subject. If not,
drawing, colouring and the ugliness of the model
might be criticized, but it was probable that the
picture would be finally condemned as objectionable,
vulgar or indecent.

There were two artists of the nineteenth century
who, by 1906, were at once heroic in their genius and
inevitably associated with compositions of nudes.
The one whose influence on Cubism is unmistakable
is Paul Cézanne. His late paintings of women bathing,

often thought to be the climax of his career, have been taken to be important influences on Picasso when he was creating the *Demoiselles*. Cézanne died in 1906, and his achievement was widely recognized as the greatest in contemporary art.

The other painter of the nude was the old master, Jean-Dominique Ingres, 'the great painter, the artful adorer of Raphael' as his contemporary Charles Baudelaire had called him in 1845. Among his many paintings of the female nude, one was unprecedented. This was the *Turkish Bath (Le Bain turc)* of 1863, finished when he was eighty-two. This circular composition of an interior filled with naked women is astounding in its blatant sensuousness. It is not excused or disguised in any way. Ingres had abandoned the goddesses of Olympus. Instead he had offered the Parisian public the concubines of a Turkish harem, stripped in their communal bath.

Picasso's friends testify to the importance of Ingres for Cubism. Salmon's list of influences on the Cubists – 'Cézanne, the Negroes, Douanier Rousseau, El Greco, Ingres, Seurat' – might, except for Seurat, be applied directly to the *Demoiselles d'Avignon*.

Picasso painted two versions of a harem scene in the summer of 1906. The more complete version, in Cleveland, shows an unmistakable debt to Ingres, both in subject and in style. The first studies for the *Demoiselles d'Avignon* show that it was intended to be a brothel scene. A clothed sailor sits among five naked women and another clothed man enters from the left. The brothel is the sordid Western alternative to the harem. It had been the chosen subject of another nineteenth-century artist, Picasso's first hero, Toulouse-Lautrec.

2 In the prolonged sequence of preliminary drawings Picasso made for the *Demoiselles,* the two men quickly disappeared. Historians have explained this by suggesting that Picasso abandoned his original idea and became engrossed in the purely pictorial prob-

11

lems he was exploring. This explanation suggests that Picasso worked like a scientist making experiments. But this seems quite untypical of Picasso's character. 'In my opinion to search means nothing in painting. To find is the thing', he said in 1923. Rather, by removing the sailors from within the composition, Picasso has turned the focus of the picture outwards. The figure on the left, which had been a man entering the room, becomes a woman, partly covered by a peignoir, drawing back a curtain to reveal the two central figures who pose *for the spectator*. The spectator was now placed as he had often been placed previously at the annual Salons; with one difference. There, he had been confronted by a scene to which a sexual response would be normal and asked to contemplate it for its artistic excellence or for its ideal beauty. Picasso has made this impossible.

The artists he emulates are men who, in 1906, were widely believed to have had little or no skill: the medieval painters of Catalonia; a Spanish painter who was considered bizarre, El Greco; a naive French painter befriended and celebrated by Picasso's circle, the Douanier Rousseau; and, most shocking of all, 'the Negroes'.

African carving was collected by most of Matisse's circle, though Picasso denied having seen Negro masks until after he had completed the *Demoiselles*. Yet the two faces on the right, the most shocking in the painting – almost certainly the faces Salmon had in mind when he recalled the horror with which the painting had been received – do strongly resemble African masks. This cannot be wholly a coincidence.

The squatting figure on the right of the final canvas is the embodiment of Picasso's most extreme innovations. In addition to the grotesque, mask-like head, the body is curiously distorted. 'It is as if the painter had moved freely around his subject, gathering information from various angles and viewpoints.

12

This dismissal of a system of perspective which had conditioned Western painting since the Renaissance marks . . . the beginning of a new era in the history of art,' wrote John Golding in his influential book *Cubism*. This figure is there from the very first composition sketch, and there she has a specific role. While the other prostitutes stand casually about, she squats facing the sailor – the client – who sits in the centre of the scene. She is unmistakably offering herself to him, with her thighs splayed apart. She is as accessible as the melon that lies split open on the table between them. But in the canvas itself the sailor has gone. The squatting Demoiselle has swivelled her head, owl-like, to stare out of the canvas. The bowl of fruit is now in the front of the canvas, between the spectator and the harlots.

Picasso has not turned his squatting figure round to display her explicitly to the spectator. Instead her whole position is ambiguous. It is clear from drawings for the painting, that Picasso was intrigued by ambiguous silhouettes: outlines that could be read as front or back views. In an oil sketch for the *Demoiselles,* her face is turned towards the spectator, but her body is a totally ambiguous outline, with conical breasts sprouting under her armpits. It is impossible to decide whether she is exposing her back or her belly.

This is the problematic torso on which Picasso abruptly placed the terrifyingly inhuman 'African-primitive' mask. There are two drawings of this time that might be studies for this head – or for a torso. Picasso has traced one face over the outline of a back. The eyes are created out of the shoulder-blades, the nose is the curving line of the spine, and the chin is one foreshortened thigh. The other sketch shows the same contour modified first into a front view of a torso, then into another similar face, but this time the eyes are the breasts and the mouth is equated with the female genitals. It is an equation that occurred in several of Goya's *Caprichos*.

2

Pablo Picasso. Study for *Les Demoiselles d'Avignon,* 1907.
Pencil drawing, $12\frac{1}{4} \times 9\frac{3}{4}$ (31.2 × 24.7).

This is the Medusa mask that 'froze with horror
the half-converted', as Salmon observed. It is an
aesthetic indecency that metaphorically transfers the
obscene display, originally made to the sailor, directly
to the spectator. The painting did not lose its original
subject. Salmon says that it was at once named *The
Philosophical Brothel;* he named it after the Carrer
d'Avinyò, a street in the Barcelona red-light area.

If Picasso's canvas was a response to Matisse's
Happiness of Living – a modern version of Ingres'
Turkish Bath – it was a cruel one. The only explanation

Pablo Picasso. Study for *Les Demoiselles d'Avignon,* 1907. Pencil drawing, $12\frac{1}{4} \times 9\frac{3}{4}$ (31.2 × 24.7).

given by anyone likely to know is that given by Salmon, who simply said that Picasso took savage artists as his mentors because 'his logic led him to think that their aim had been the genuine representation of a being, not the realization of the idea we have of it'. He has taken Ingres's dream of houris, swooning languorously in an Oriental bathhouse, and given it the *realistic* savagery of a 'truly' primitive style.

Matisse and Leo Stein were very angry when they saw the *Demoiselles.* They laughed and said Picasso was trying to create a fourth dimension. It was at this

time that Georges Braque was brought on his first visit to the Bateau Lavoir. When he saw the *Demoiselles* he too was shocked. He said to Picasso: 'Despite all your explanations, you paint as if you wanted us to eat rope-ends or to drink petrol.'

Braque was only six months younger than Picasso, but he was not a prodigy. It was at the Salon des Indépendants held in March 1907 (when Picasso was already at work on the *Demoiselles*) that he had his first professional success. He sold all six pictures he was exhibiting. His work was noticed by a young German dealer, Daniel-Henry Kahnweiler, who had just opened a gallery in Paris. That October, he signed a contract to buy Braque's entire production. He also introduced him to Apollinaire. Apollinaire naturally introduced him to Picasso.

Whatever Braque thought of the *Demoiselles* when he first saw it, it must have made a profound impression on him. The paintings with which he had been so successful at the Salon des Indépendants that Spring had been Fauve, but soon after his visit to Picasso's studio he began work on a quite different subject and kind of painting. This was a medium-sized painting of a nude which occupied him for the following six months. Everything about this painting suggests that after seeing the *Demoiselles* he set out deliberately to transform his way of painting.

The influence of the *Demoiselles* can be seen in many features of Braque's *Nude*. Most striking is the empty-eyed mask which is turned to stare blankly at the spectator over a shoulder. The vigorous outlines, too, suggests the *Demoiselles'* effect. Like the *Demoiselles*, it is placed against drapery that is sculpted into hard, angular folds. And just as in Picasso's invention, the spatial orientation is obscure. The Demoiselle in the pink peignoir draws back a brown curtain to reveal a milky blue sky which is itself a curtain parted to reveal another darker interior. The Demoiselle with one arm raised was, in the earliest drawings,

sitting on a chair. Now she appears to stand, or rather to slide to one side; her pose is almost the same as that of the famous Venus painted in sixteenth-century Venice by Giorgione, that now known as the Dresden Venus, except that Giorgione's Venus is lying down. Braque's nude looks most uncomfortably balanced on the toes of her right foot, but appears much more at ease if she is seen as lying down, shown from above. There is nothing to allow the spectator to make a decision between these possibilities.

Despite its striking kinship with the *Demoiselles,* Braque's *Nude* marks the beginning of Cubism in a way that Picasso's picture does not. For much of 1908, Picasso followed the implications of his inventions of 1906. His preoccupations were with solid, sculptural forms and bold shapes. This time has been called his 'Negro' period, and even the works which do not resemble African art are *primitive* in their harshness and crudity. Braque, on the other hand, developed from his *Nude* in a different direction. Throughout 1908, he showed, more and more strikingly, the influence of Cézanne. It was Braque's work of 1908 that was first called 'Cubist'. This was by Matisse, who was one of the jury that rejected all the new paintings Braque submitted to the Salon d'Automne of that year. Despite this, these canvases were shown, at Kahnweiler's gallery, that October. Louis Vauxcelles noted that Braque reduced everything to cubes.

Perhaps it was from that time that Picasso began to regard Braque's work seriously. Certainly it was from then that Cubism began to grow. Between then and 1914, the work of Picasso and Braque passed through several transformations, and in retrospect these developments look inevitable, even logical. But true Cubism, this painting of Picasso and Braque, was not the result of a programme, a project. It flourished out of the friendship and rivalry of these two. Braque described the following years: 'We lived in Montmartre, we saw each other every day, we talked.

17

During those years Picasso and I discussed things which nobody will ever discuss again, which nobody else would know how to discuss, which nobody else would know how to understand.' In his memorable phrase, he and Picasso were like 'two mountaineers roped together'. There came a moment when they had difficulty in distinguishing between their paintings. They valued this similarity and abandoned signing their works on the front, leaving it to the assistant of their dealer, Kahnweiler, to identify the work on the back only.

6, 7 Braque, in the landscapes painted at L'Estaque in 1908, crystallized the essential qualities of Cubism. From Cézanne, Braque learned a great deal. He learned, first of all, to avoid strong diagonals, foreshortening and other perspectival devices that would give clear indications of depth in the traditional way of Western painting. He learned to see or invent patterns in which objects in quite different planes in three dimensions could be balanced two-dimensionally. For example, a tree rising on the right of a canvas will be balanced by a path on the left, and these two curved shapes will between them bracket the landscape. A third device that Braque adapted from Cézanne was to avoid closed contours, to leave gaps in outlines: this allowed objects in quite different planes to melt into each other as they were juxtaposed in the pictorial composition; and it also emphasized the independence of the outline as a pictorial element.

Braque's landscapes were quite unlike those of Cézanne in two significant ways. Cézanne learned from the Impressionists, and his canvases glowed with sunlight; Braque's palette was almost monochromatic (perhaps in reaction against his Fauve days), and he often used a neutral grey. Cézanne's outline was quivering, tentative; Braque drew with an aggressive, bold stroke. Cézanne seemed to contemplate the world, searching for its significance; Braque remade the world as his art demanded it.

From early in 1909, the differences between Picasso's 'Negro' style and Braque's post-Cézanne style diminished and disappeared. They created an art which was, as critics had said of Matisse's Fauvism, theoretical and artificial, but which, unlike Fauve painting, seemed to be about the *substance* of things. Much later, Braque was explicit about his interest in abandoning traditional perspective: 'It was too mechanical to allow one to take full possession of things.' It is a paradox of much Cubist painting, and especially that of Braque, that though it is often hard to know *what* is represented, or even *where* it is meant to be, that unknown, uncertain object is undeniably tangible.

There is no mystery about this. It is the result of the Cubist use of the *facet* as the basic element of painting. This had been Picasso's fundamental technical innovation in the *Demoiselles d'Avignon*. The facet, not the cube, is the key to this art. The facet may vary in size, but its basic features survive from 1908 to 1913. It is a small area bordered by straight or curved lines, two adjacent edges defined with a light tone and two opposite edges with a dark tone, and the area between modulating between these extremes. The tonal effect would suggest a strongly convex or concave surface, but this is denied by the edges of the facet.

The facets are composed according to three principles. First, they are almost always painted as if at a slight angle to the vertical surface of the canvas; that is to say, they are like louvres of a window that are usually ajar, but never fully opened at right-angles to the frame. Secondly, although the facets overlap and cast shadows on each other, the shadows and overlappings are inconsistent; it would be impossible to construct a relief model of a Cubist painting. Thirdly, the edges of facets dissolve, allowing their contents to leak into each other in the manner the Cubists had learnt from Cézanne.

Thus these facets, apparently in low relief, painted

8, 9

19

in traditional chiaroscuro, and so tangible, real, are structured in a baffling paradoxical system that defies immediate identification. Nevertheless, they do represent very real, commonplace objects, pipes, bottles, musical instruments, the possessions of the artists' lives – or are even portraits of their friends and mistresses.

The first phase of Cubism was that created by the fusion of Picasso's primitivism with Braque's post-Cézanne forms. This was the time of bold simplifications into heavy blocks of form. Its monumentality was lightened by the ambiguity of the shapes and by avoidance of the foreshortening that would have given the objects a convincing three-dimensional existence.

Out of this sculptural imagery grew the paradoxical figures of 1910. In this phase unmistakably solid objects were represented in spaces that often appeared profound. But the dimensions of objects and spaces are uncertain, even elusive. In the Tate Gallery, London, are two paintings from this time, a *Seated Nude* by Picasso and *Still-life with Herrings* by Braque. Each painting conveys a strong sense of deep space, of the shifting light and shade of a gloomy studio interior; but each is obscure in other ways. Braque's still-life might, at first sight, be a landscape with factory chimneys. Certainly the herrings of the title are hard to identify immediately. Some major forms in the painting never resolve themselves, are irresoluble. But the space in which these objects are suspended, the light that flows about them like a sluggish, ebbing tide – *these* are pictorial forms compelling in their presence.

Picasso's *Seated Nude* of 1910 is enigmatic in another way. The canvas is covered with intersecting diagonals of lighter and darker paint of sombre tones. The surface is homogeneous, and yet it is not difficult to identify the figure sitting in a chair and, beyond her shoulder, the distant clutter of a studio. The chair,

like the table on which Braque's *Still-life with Herrings* is placed, is drawn in conventional perspective. But the torso framed by its arms is harshly defined, as if assembled perfunctorily from old picture frames and the discarded wooden stretchers of old canvases. It is the head that is totally ambiguous: is it raised to stare out beyond the spectator's left shoulder, or lowered in reverie?

By this time, Picasso and Braque had developed an alternative process of representation that was as flexible and expressive as that of the schools. This may be seen by comparing the Tate Gallery *Seated Nude* with another by Picasso, *Girl with a Mandoline,* in a private collection in New York. The Tate painting is an emblem of brooding melancholy, whereas in contrast the New York nude is far more sensuous. Again, look at Picasso's portrait of his dealer, Ambroise Vollard. It is an excellent likeness. The bulldog muzzle clamped shut is firmly defined. The dome of the skull, though, has been offered as several alternative outlines. This time the language is used to suggest the process by which the artist, fascinated by those clenched, immovable jaws, found that his perception of the top of the head shifted with each successive glance.

Within a few months, the process developed further. In Picasso's portrait of Kahnweiler, the dealer and the objects around him, pictures, books, bottles, are reduced to facets that, like cards overlapping, flutter across the canvas surface. The facets themselves dissolve in a flux of light and dark. In the paintings that follow, the object represented is almost lost within the crystalline faceting that dominates the picture surface. The paint is often applied in regular small dabs, something like bricks placed horizontally but loosely across a firmer grid of lines, vertical, horizontal and in diagonals of 60° and 30°. In these structures the eye could wander as if in a maze. First one set of shapes drifts to the surface; then, by a

21

sleight of perception, it sinks back and an alternative conformation replaces it. But at this point the painter inserts a clue: an eye blinks out among the parallelograms, two sagging lines become a watch-chain, or a series of black studs become the pegs of a mandoline. The title becomes crucial as a key to the mystery. First Braque, then Picasso, uses lettering to clarify his meaning.

This is the extreme phase of true Cubism that has been called 'hermetic', the ultimate 'analysis' of the object. It is, rather, the most extreme refinement of representational obliquity. In a still-life that after contemplation resolves into a newspaper and glass on a café table, Braque uses the unpainted canvas to represent all the *objects* in his still-life and uses a heavy impasto to create the airy intervals around them.

Although Braque followed Picasso's example, and (after showing two pictures at the juryless Salon des Indépendants in Spring 1909) did not exhibit publicly in Paris until after the First World War, Cubism was becoming known. Other painters visited their studios, and in the Salon d'Automne of 1910 there were enough works painted under the influence of Picasso's and Braque's new style to attract critical attention. These painters included Jean Metzinger, Henri Le Fauconnier, Robert Delaunay, Albert Gleizes and Fernand Léger. This group organized itself to take over the hanging committee of the Salon des Indépendants the following Spring and so transformed the esoteric achievement of Picasso and Braque into an Art Movement.

The response of *la bande à Picasso* to the new Cubists may be deduced from Gertrude Stein's description of Robert Delaunay. He was, she wrote, 'the founder of the first of the many vulgarizations of the cubist idea, the painting of houses out of plumb, what was called the catastrophic school. . . . He was fairly able and inordinately ambitious. He was always

19

22

asking how old Picasso had been when he had painted a certain picture. When he was told he always said, oh I am not as old as that yet. I will do as much when I am that age.'

But for the general public, the Cubism of these followers was the only Cubism to be seen. In 1911, the Cubist Movement exhibited at the Indépendants in Spring, at the Société des Artistes Indépendants in Brussels in June, and at the Salon d'Automne in October. These *bizzareries cubiques,* as Vauxcelles called them, attracted attention and called for explanation. The following year, 1912, a spate of articles and pamphlets were published to explain what Cubism was about. The explanations were various but there was general agreement on one thing: that the Cubists were realists; they did want to paint representational pictures, but believed that traditional methods of representation were false. Olivier-Hourcade, a writer best known for his defence of Cubism, explained: 'The ruling preoccupation of the [new] artists is with cutting into the essential TRUTH of the thing they wish to represent, and not merely the external and passing aspect of this truth.' Hourcade invoked the German philosophers Kant and Schopenhauer to insist on the distinction between 'that which appears and that which is . . . between the thing and us there is always the intelligence'. Then he gave a crucial example. 'The painter, when he has to draw a round cup, knows very well that the opening of the cup is a circle. When he draws an ellipse, therefore, he is not sincere, he is making a concession to the lies of optics and perspective, he is telling a deliberate lie.'

In 1912 a quite different explanation and theory was offered in a book written by two painters, Albert Gleizes and Jean Metzinger, who had become, by this time, leaders of the Cubist Movement. Like other interpreters, Gleizes and Metzinger said that Cubism was concerned with reality, and like others they said that 'the visible world only becomes the real world by

the operation of thought'. But whereas those others argued that the reality sought by painters was the eternal truth – the thing-in-itself – that lay behind the partial images revealed by our senses, Gleizes and Metzinger denied this. 'According to (certain other critics),' they wrote, 'the object possesses an absolute form, an essential form, and, in order to uncover it, we should suppress chiaroscuro and traditional perspective. What naivety! An object has not one absolute form, it has several; it has as many as there are planes in the domain of meaning.' 'To the eyes of most people the external world is amorphous. To discern a form is to verify it against a pre-existing idea, an act that no one, save the man we call an artist, can accomplish without external assistance.'

The artist, they argue, imposes his vision of the world on the rest of humanity. Therefore whenever an artist with a new vision appears his work is at first rejected as false because the crowd remains a slave to earlier painted images and 'persists in seeing the world only through the already adopted sign'.

By comparison with the theories of outsiders and followers, Picasso and Braque have given little explanation of their interests or the subject matter of those long, incomprehensible conversations that Braque remembered so nostalgically. Braque did make a number of brief statements throughout his life, the earliest being to an American interviewer in 1908. His views remained remarkably consistent. His concern was with reality; but it was a reality of the mind, not of the senses. 'There is no certainty except in what the mind conceives.' And reality must be represented not by imitating appearances, but by an intuitive exploration of the medium.

Picasso did not commit himself on his art until 1923. Then he emphasized the artificality of art. 'Art is a lie that makes us realize the truth. . . . They speak of naturalism in opposition to modern painting. I would like to know if anyone has ever seen a natural

work of art.' Velázquez and Rubens both painted Philip IV of Spain, said Picasso, but we believe only in the Philip of Velázquez. 'He convinces of his right by might.'

In short, while the sympathetic onlookers, from Olivier-Hourcade to Kahnweiler, claimed that Cubism was concerned with the eternal truth hidden by appearances, and evoked the name of Kant to give substance to their explanation, those on the inside, from Gleizes and Metzinger to Picasso, said with varying degrees of firmness that there was no eternal truth. Truth, they said, was illusion imposed by the strong on the multitude of the weak. In this they were themselves influenced by another German philosopher, Friedrich Nietzsche. He is the only philosopher mentioned by name by Apollinaire, Salmon and Braque when discussing Cubism. (Picasso's view of art seems a direct adaptation of Nietzsche's words: 'art, in which precisely the *lie* is sanctified and the will to deception has a good conscience'.)

But though Nietzsche, the creator of Zarathustra and the Superman, author of *The Will to Power,* was certainly read and admired by the circle round Picasso, his influence probably worked most powerfully indirectly, through the character and writing of another acquaintance of the group, the writer Alfred Jarry. Jarry first became notorious at the age of twenty-three, with his play *Ubu roi,* a grotesque burlesque fantasy. Soon, Jarry himself became a scandal, living a fantasy life of absurd extremism. His novel *Le Surmâle,* the Supermale, of 1902, which was an outrageous combination of science-fiction and pornography, had a hero who demonstrated that a man could do everything he decided he wanted to do – physical limitations were a fiction of conventional social values. *Le Surmâle* was Nietzsche's superman made comic.

It is hard to insist that a serious art is also deliberately absurd : clearly the Cubism of Picasso and Braque was

much else besides. But it would be quite wrong to ignore the high value placed on the comic, on playfulness, on wit, in Picasso's circle. The regard for Jarry speaks for this, and Gertrude Stein's description of Picasso and Braque together is at once comical and revealing. She describes them visiting the dealer Wilhelm Uhde. 'He kept a kind of private art shop. It was here that Braque and Picasso went to see him in their newest and roughest clothes and in their best cirque Medrano fashion kept up a constant fire of introducing each other to him and asking each other to introduce each other.'

It was a double act in which each partner was raised to greater brilliance by the rivalry than either could ever achieve alone. Certainly, neither Picasso or Braque ever painted better than in the Cubist years.

They were creating an *alternative* art, just as Jarry created alternative worlds in his absurd fantasies. It cannot have been mere coincidence that these two abandoned what has been called 'Analytical Cubism' in 1912, just when versions and explanations of it were becoming commonplace. This was when they began to use collage, a 'synthetic' method, sticking objects on to their canvases instead of painting them. This has been explained in various ways : Braque himself said that he used shapes cut from paper to give his shapes a kind of factualness, a kind of certainty. And yet this is not quite the impression created by the works themselves.

First, by using scraps of newspaper, old cigarette-packets and the flimsy detritus of modern life, they made these new works hard to take. The public which had learned to admire the obscurity of Analytical Cubism had to reverse its values to like this crude pasting-together of rubbish.

Then again, the objects stuck on to their pictures did not inevitably make them more real. On the contrary, the first time Picasso stuck anything on a picture it was a piece of oilcloth printed by the

16

manufacturer to resemble chair caning. Both he and Braque delighted in fake textures and surfaces.

And finally, Picasso delighted in the humour that collage made possible. He stuck the conventionally realistic apples and pears from a horticultural catalogue on to a fruit dish cut out of newspaper. In general, he exploited collage to tease and amuse his spectator with witty transformations of familiar images.

Cubism was a self-consciously esoteric, difficult art. The value of Apollinaire to Cubism, Braque said rather unkindly, was that his book on Cubism, far from enlightening people, only succeeded in bamboozling them. And much later, after attempting to explain a little of Cubism, he added: 'but the only value of all this is that it should remain a mystery'.

Gleizes and Metzinger ended their book on Cubism with a few sentences that are usually ignored: 'For the partial liberties conquered by Courbet, Manet, Cézanne and the Impressionists, Cubism substitutes an indefinite liberty. Henceforth, objective knowledge at last regarded as chimerical, and all that the crowd understands by natural form proven to be convention, the painter will know no other laws than those of Taste. . . . [In the depths of science] one finds nothing but love and desire. A realist, [the artist] will fashion the real in the image of his mind, for there is only one truth, ours, when we impose it on everyone. And it is the faith in Beauty which provides the necessary strength.'

It is a statement that bridges Nietzsche and the Surrealists. It will serve to remind us that Picasso's last great Cubist work, the *Three Dancers* of 1925, is also one of the masterpieces of Surrealism.

I have confined myself to the achievement of Picasso and Braque, and I believe that my reasons for doing so will be clear by now. There were, however, a considerable number of painters who painted Cubist works during the period between 1908 and the First

World War. The majority of these were the painters who took part in the Cubist Movement, exhibiting together at the Salon des Indépendants, the Salon d'Automne and elsewhere. There were, in 1912, no fewer than three different groups of Cubists: that formed by Robert Delaunay; the nucleus of the original group centred round Gleizes and Metzinger who now called themselves 'Les Artistes de Passy'; and a group that called itself 'La Section d'Or' and was based in the suburb of Puteaux in the studios of three brothers, Jacques Villon, Marcel Duchamp and Raymond Duchamp-Villon. It seems probable that these groups became militantly Cubist in response to the exhibition and demonstration of Futurist art held in Paris in February 1912.

The majority were minor talents, and had they not taken part in the movement would seldom be remembered. These include Gleizes, Metzinger, Herbin, Le Fauconnier, Lhote, Marcoussis and other even lesser figures. There were also artists of real stature who were young enough to pass through Cubism as a form of adolescence before discovering their own styles. The most important of these were Robert Delaunay, Marcel Duchamp and Fernand Léger, though innumerable painters of all nationalities, artists as different as Chagall and Klee, also felt the influence of Cubism.

This leaves André Derain and Juan Gris. Derain had been a powerful innovator among the Fauves. He was one of Picasso's circle, and there is no doubt that in 1907 he looked a daring and original artist. However, though he painted a number of works which show the influence of Cézanne, he never painted anything that might properly be called Cubist. As I have suggested earlier, it was Apollinaire who out of friendship insisted that Derain had played a major role in the creation of Cubism. Juan Gris, a Spaniard six years younger than Picasso, has been called the third of the true Cubists, but in my view this is unwarranted. He

did know Picasso well, he lived in the Bateau Lavoir, and he was certainly talented: he was a better Cubist than any other follower. Between 1913 and 1915, he **23, 24** painted works incorporating collage that could be placed beside the most brilliant of Picasso's works of those years. But his later works became mannered and repetitive, reducing the spontaneity and wit that had been the heart of true Cubism to elegant decoration.

Futurism

Futurism was a movement: it lived on publicity. It was announced in a manifesto published in French on the front page of the Paris newspaper *Le Figaro* on 20 February 1909, while hundreds of copies in Italian were sent to leading figures all over Italy. Between then and the outbreak of the First World War, over a dozen further manifestos were published and were accompanied by countless articles in the press. During the same period, there were Futurist demonstrations

Umberto Boccioni. *Futurist Evening in Milan,* 1911.

and exhibitions in theatres and galleries at towns throughout Italy and in Paris, London, Berlin, Brussels, Amsterdam, Munich, Rotterdam, Moscow and Petrograd.

It was an international movement conceived by an Italian, Filippo Tommaso Marinetti. Marinetti had a strange history. His father settled in Egypt and made a fortune speculating and advising the Khedive of Alexandria. In 1893, Filippo Tommaso Marinetti went to Paris and studied at the Sorbonne. He soon became known in the Symbolist circles of Paris. Much later he remembered himself and Alfred Jarry, 'the most threadbare genius in the world', in the ornate salon of Mme Périer, where 'I toss off my ode on the speed of cars and Jarry his metamorphosis of a bus into an elephant'. Marinetti's play *Le Roi Bombance* was unmistakably influenced by Jarry's *Ubu roi*; both were staged in Paris by Lugné-Poë, and both were greeted by a riot. From Paris Marinetti went, in 1895, first to Pavia and then to Genoa to study law. However, his elder brother, his mother and his father all died within a few years, and Marinetti inherited a considerable fortune. He settled in Milan and set about the renovation of Italian letters. In 1905 he founded his own periodical, *Poesia*. But, as Apollinaire wrote rather tartly in 1912, 'to awaken Italy from its torpor, he has taken France as his model because France is the leader in the arts and in literature'.

The 1909 'Founding and First Manifesto of Futurism' is best known for its eleven principles which glorify action and violence and vilify tradition of every kind. 'The essential elements of our poetry will be courage, audacity, and revolt. We wish to exalt too aggressive movement, feverish insomnia, running, the perilous leap, the cuff, the blow.' This cult of violence, the belief that 'there is no more beauty except in struggle' (axiom 7), culminated in the notorious axioms 9 and 10:

'We will glorify war – the world's only hygiene – militarism, patriotism, the destructive gesture of the Anarchist, the beautiful ideas that kill, contempt for woman.

'We will destroy museums and libraries, and fight against moralism, feminism, and all utilitarian cowardice.'

The past was past, museums were cemeteries. 'We declare that the splendour of the world has been enriched by a new form of beauty, the beauty of speed. A racing-car adorned with great pipes like serpents with explosive breath – a roaring racing-car that seems to run on shrapnel, is more beautiful than the *Victory of Samothrace*.'

More revealing even than the eleven points of the Manifesto is Marinetti's way of presenting them. He describes the events which led to the moment of their proclamation. 'We had been up all night, my friends and I, under the Oriental lamps with their pierced copper domes starred like our souls – for from them too burst the trapped lightning of an electric heart. . . . An immense pride swelled our chests because we felt ourselves alone at that hour, alert and upright like magnificent beacons and advance posts confronting the army of enemy stars staring down from their heavenly encampments. Alone with the stokers working before the infernal fires of the great ships; alone with the black phantoms that poke into the red-hot bellies of locomotives launched at mad speed; alone with the drunks reeling with their uncertain flapping of wings around city walls.'

This is very similar to the feeling of *difference,* of the artist's superiority, prevailing in nineteenth-century Romantic writing, typical of Edgar Allan Poe or Théophile Gautier. But, where Gautier uses similar images to present his account of smoking opium, Marinetti is using the ethic of Romanticism to attack Romantic values. He and his friends leave the Oriental luxury (which, incidentally, is a literal account of his

apartment) for the streets of Milan, an ancient, crumbling city that within the previous few years had become modernized. Marinetti contrasts the moribund palaces and stagnant canals with 'the formidable sound of the enormous double-decked trams that jolted past, magnificent in multicoloured lights like villages at holiday time that the flooded Po has suddenly rocked and wrenched from their foundations'. There, they find 'three snorting beasts' – their new automobiles. 'Let's go!' Marinetti cries. 'Let's go, friends! Let us go out. Mythology and the Mystic Ideal are finally overcome. We are about to witness the birth of the centaur and soon we shall see the first angels fly! – The doors of life must be shaken to test the hinges and bolts! – Let's take off! Behold the very first dawn on earth!'

This furious drive becomes, in Marinetti's account, an epitome of existence. He flourishes all the metaphors and images of Romanticism to dismiss them as valueless – but also to destroy the notion of value itself. Sitting behind the steering wheel that is like a guillotine blade, himself like a corpse in a coffin, he scorches along, squashing dogs under his tyres, until he at last skids into a ditch. But the car is resurrected, and it is as it speeds away again that the driver declaims the eleven principles of Futurism.

The only value is action. Man may become whatever he wills. He does not need to imagine angels and centaurs, because he is a centaur (in his automobile), an angel (in his aeroplane). But Marinetti not only dismisses traditional ideals – the very notion of the Ideal – but despises rationality: 'Let's break away from rationality as out of a horrible husk. . . . Let's give ourselves up to the unknown, not out of desperation but to plumb the depths of the absurd!'

Marinetti's 'Founding and First Manifesto of Futurism' is a call to a new form of life. The artist must be the Hero. Art is a form – the only true form – of action. Although Marinetti had brought together

strands of thought from many nineteenth-century sources, his true mentor was Nietzsche: his 'dithyrambic' style is that of *Thus Spake Zarathustra*; his Hero is Nietzsche's Superman. He concludes with a startling image.

'The oldest among us are thirty. . . . When we are forty, let others – younger and more daring men – throw us into the wastepaper basket like useless manuscripts! They . . . will rush to kill us, their hatred so much the stronger as their hearts will be overwhelmed with love and admiration for us! And powerful and healthy Injustice will then burst radiantly in their eyes. For art can only be violence, cruelty, and injustice.'

There are two kinds of problem set by this First Manifesto. First, and most profoundly, it is against most known, accepted, civilized values. It agrees implicitly with Nietzsche, when he wrote: 'The *meaning of all culture* is the reduction of the beast of prey "man" to a tame and civilized animal, a *domestic animal* . . . but who would not a hundred times sooner fear where one can also admire than *not* fear but be permanently condemned to the repellent sight of the ill-constituted, dwarfed, atrophied and poisoned?' (*Genealogy of Morals,* I, 11.) This is a *moral* problem. The second problem is more technical; a problem for the artist. Its ideal of art is clearly similar to the state that in his *Birth of Tragedy* Nietzsche had called Dionysiac: 'no longer the *artist*, he has himself become a *work of art:* the productive power of the whole universe is now manifest in his transport.' If Futurism was a state of being, an ethical condition, what were the consequences for the traditional forms of art?

It is clear from a reading of the First Manifesto that it offers a credo embracing all the arts and giving guidance to none. Marinetti himself saw Futurism as embracing all aspects of human activity. Drawn by his vigorous activity, a number of writers, painters, sculptors and other artists became Futurists. The First

Manifesto was followed by manifestos on Futurist painting, sculpture, music, photography, architecture, noises and clothes. Marinetti himself signed manifestos, written either individually or in concert with friends, on literature, cinema, theatre and politics. On 11 March 1915, Giacomo Balla and Fortunato Depero issued a manifesto on the 'Futurist Reconstruction of the Universe'.

Given the Futurist ethos as defined by Marinetti, what *form* was Futurist painting, sculpture, literature, music or theatre to take? Marinetti faced this problem as a poet in his 'Technical Manifesto of Futurist Literature' of 11 May 1912, which began: 'Sitting on the gas tank of an aeroplane, my stomach warmed by the pilot's head, I sensed the ridiculous inanity of the old syntax inherited from Homer.' Most important, though, was the principle 'Destroy the *I* in literature: that is, all psychology' and instead substitute an *intuitive psychology of matter,* the principle revealed to Marinetti in the aeroplane. In this way the writer could invent 'wireless imagination', *words-in-freedom*. 'Futurist poets!' he concluded, 'I have taught you to hate libraries and museums, to prepare you *to hate intelligence*, reawakening in you divine intution, characteristic gift of the Latin races. Through intuition we will conquer the seemingly unconquerable hostility that separates human flesh from the metal of motors.'

The problem of how to *be* Futurist was felt acutely by the painters; and the painters were the first to become Futurist. Soon after the publication of Marinetti's First Manifesto, a number of Italian painters, who included Umberto Boccioni, Carlo Carrà and Luigi Russolo, introduced themselves to him and, according to Carrà's recollection, drew up their own 'Manifesto of the Futurist Painters'. This was eventually published by proclamation to an audience from the stage of the Politeama Chiarella, Turin, on 8 March 1910. (The date attributed to the

manifesto is 11 February 1910, as Marinetti favoured the number eleven.) It was addressed to the young artists of Italy, and was a hollow sequel to Marinetti's First Manifesto. It deplored the decadence of contemporary Italian art, still exploiting 'the glories of the ancient Romans', and demanded a new art that would reflect 'the frenetic life of our great cities and the exciting new psychology of night-life; the feverish figures of the bon viveur, the cocotte, the apache and the absinthe drinker.' It was tame stuff. Principle 8, in particular, was a very prosaic sequel to Marinetti's explosive poetry. 'Support and glory in our day-to-day world, a world which is going to be continually and splendidly transformed by victorious Science.' Two other painters, Giacomo Balla and Gino Severini, joined Boccioni, Carrà and Russolo in signing this manifesto, but none of them, at that point, had painted anything that deserved the name Futurist. It is not certain that they had any idea of how this could be done.

However, the same five quickly followed this with the 'Futurist Painting: Technical Manifesto' published on 11 April 1910. 'The gesture which we would reproduce on canvas shall no longer be a fixed *moment* in universal dynamism. It shall simply be the *dynamic sensation* itself. . . . On account of the persistency of an image upon the retina, moving objects constantly multiply themselves; their form changes like rapid vibrations, in their mad career. Thus a running horse has not four legs, but twenty, and their movements are triangular.'

In other words, the Futurists first conceived their new art as an attempt to show the world, not as it really was, but as it was *really experienced*. But though their theory called for a 'sharpened and multiplied sensitiveness', in practice they replaced the conventions of the museums with those of photography and a current theory of colour. In their representation of movement they were influenced by the multiple

E. J. Marey. *Chronophotograph,* 1887 (?).

exposures of moving figures made and published in the last years of the nineteenth century by E. J. Marey. Their colour was based on Pointillism or Neo-Impressionism – patterning with touches of pure colour – first developed in the 1880s by the French painter Georges Seurat.

Nevertheless, despite the manifesto's ingenuous concentration on dynamic sensation, only one of the Futurists was consistently concerned with the representation of movement. This was Giacomo Balla, the oldest of the group and the teacher of Boccioni and Severini. Although it was he who first introduced the group to the practice of Neo-Impressionism, and although he had agreed to sign the first 'Manifesto of Futurist Painting', he did himself not paint a certainly Futurist work until 1912. Then, abruptly, after a visit to Düsseldorf, he painted, in a little over a year, a brilliant series of paintings of movement. The earliest and best known, *Dynamism of a Dog on a Leash*, is also the least impressive. It is so clearly based

26

Giacomo Balla. Study for *Girl Running on a Balcony,* 1912. Collection Balla, Rome.

on the study of multiple-exposure photographs. *Rhythm of a Violinist* is similar, but the use of prismatic strokes of colour to represent the disintegration of the hand into a vibrating pattern of lines is ingenious. *Girl Running on a Balcony* is more than ingenious. It too is unmistakably derived from Marey's photographs, but Balla dissolved the entire surface into a mosaic of coloured dabs in the Neo-Impressionist manner. In this way the spectator has simultaneously to form the dabs into a single figure (the girl) and see the girl as moving (in several blurred stages) across the balcony. Finally, there is a neat contrast between the repeated representations of the parts of the girl, each of which is the same individual at different points of time, and the repeated verticals which are different railings stationary at different points in space. Even his later paintings of swifts in flight (taken again from Marey), and of an automobile in movement, are simply heightened sequels to this image. Quite different, and altogether strange, are the

29

28

27

30 series of totally abstract paintings of 1912, the *Iri-*
31 *descent Interpenetrations,* which he developed out of
his study of light and colour.

Despite his seniority, or perhaps because of it, Balla
was not representative of Futurist painting at any
time. Perhaps the first impressively Futurist paintings
32 were by Carlo Carrà. *The Swimmers* of 1910 and
34 *Leaving the Theatre* of 1910–11 are his first inventions,
33 but his most complete painting came with the *Funeral
of the Anarchist Galli* of 1910–11. Angelo Galli had
been killed during the general strike in Milan in 1904.
Carrà had seen the riot that had developed at his
funeral, when clashes between police and workers
had almost knocked the red-draped coffin to the
ground. In his painting he represents the fight not as a
moment between individuals but as a clash of lines
and colours. The figures are anonymous and their
limbs blur into sheaves of lines representing their
movement. Carrà was certainly influenced by Marey's
photographs, but his theme is unmistakably more
complex than the mere representation of physical
movement.

Luigi Russolo, who was the youngest of the five
painters, was also the most extreme. He was a trained
musician and spent a great deal of time developing a
Futurist art of noises. He issued a manifesto on the
'Art of Noises' on 11 March 1913, in which he de-
clared: 'For many years Beethoven and Wagner shook
our nerves and hearts. Now we are satiated and WE
FIND FAR MORE ENJOYMENT IN THE COMBINATION OF
THE NOISES OF TRAMS, BACKFIRING MOTORS, CARRIAGES
AND BAWLING CROWDS THAN IN REHEARSING, for
example, THE "EROICA" OR THE "PASTORAL".' On 21
May 1914, he gave a concert of noises – many pro-
duced by devices of his own invention – at the Teatro
Dal Verme, Milan. As a painter, Russolo was self-
taught and less impressive, but here too he was ambi-
tious and ingenious. He was the first of the Futurists
to explore the possibilities of synaesthesia. This is the

association of the experiences of one sense with those of another, as when a colour feels hot or cold, or a musical composition is colourful, and especially when any set of shapes, colours, sounds or tastes seem to evoke a mood or state of mind. Kandinsky, in Munich, expounded a theory of synaesthesia in his *Concerning the Spiritual in Art,* and after its publication in 1912 several Futurists issued manifestos on it as a Futurist phenomenon.

Russolo first painted a picture in which the impressions of one sense were represented in terms of another when, in 1909, he painted *Perfume*. It is a weak, sentimental picture, badly drawn, but attempts to represent the erotic quality of the woman's odour by enveloping wavy lines of brilliant colour. *Music* of 1911 became a set-piece of Futurism. The pianist crouches satanically over the keyboard, several hands feverishly pounding out the music that swirls in a visible polychrome wave above his head. Around him the spirits of the composition are represented by garish sightless masks. It is, however, his *Memories of a Night* of 1911 that is truly representative of Futurist ambitions. It is a disjointed composition, with slouching figures, street-lights, houses, horses, women's heads and other details placed in uncertain juxtaposition. But, as its title reveals, it is not concerned with a specific incident, a certain place, or even a certain precise time, but with the nature of experience. Here, the Futurists were influenced by the popular French philosopher Henri Bergson, who pointed out that perception and experience were not instantaneous. Memory played a fundamental role in our experience, which was inevitably extended over time. *Memories of a Night* and *Solidity of Fog* blend such effects of the persistence of vision as are instanced in the 'Manifesto of the Futurist Painters' within a larger panorama.

It was during 1911 that several of the Futurist painters visited Paris. The reason seems to have been

41

38

36

37

that Gino Severini, a signatory of the manifestos, who lived in Paris, persuaded the others that their work would improve if they could visit the studios of the Cubists. Whatever the reason, late in the year, Boccioni and Carrà went to Paris, and Severini introduced them to his friends and acquaintances as well as taking them to the Salon d'Automne where there were works by Metzinger, Gleizes, Léger, Le Fauconnier, La Fresnaye and others. They also visited Picasso's studio, where they met Apollinaire, who recorded the visit in his gossip column in the *Mercure de France*.

'I have met two Futurist painters, M. Boccioni and M. Severini. . . . These gentlemen wear clothes of English cut, very comfortable. M. Severini, a native of Tuscany, favours low shoes and socks of different colours. . . . This Florentine coquetry exposes him to the risk of being thought absent-minded, and he told me that café waiters often feel obliged to call his attention to what they suppose is an oversight, but which is actually an affectation. I have not yet seen any Futurist paintings, but, if I have correctly understood what the new Italian painters are aiming at in their experiments, they are concerned above all with expressing feelings, almost states of mind (the term was employed by M. Boccioni himself). . . . Furthermore, these young men want to move away from natural forms and to be the inventors of their art.

'"So," M. Boccioni told me, "I have painted two pictures, one expressing departure and the other arrival. The scene is a railway station. In order to emphasize the difference of moods I have not repeated in the arrival picture a single line in the other."'

Apollinaire thought that this kind of painting 'would seem to be above all sentimental and rather puerile'.

Boccioni was, as Apollinaire discovered, the theoretician of the group. He was also the most talented. Nevertheless, he was (with the exception of

his teacher Balla) the last of the painters to develop a distinctive Futurist form. He was a year younger than Picasso. For a short time, in 1901, he studied with Severini in Balla's studio in Rome, and his early work shows Balla's influence, particularly in his use of a Neo-Impressionist palette. Many of the drawings he made when he was in his middle twenties have something of the harsh solidity of early drawings by Van Gogh. He was, until 1908, an able but unoriginal member of the Italian Neo-Impressionist school that included Balla, Segantini and Previati.

It was then that he apparently became dissatisfied with this tradition of Impressionist realism. He began to explore the varieties of modernism which, as they were available to him, were forms of Art Nouveau and Symbolism. It was then that he discovered Marinetti and Futurism. Boccioni's first Futurist works illustrate that the movement was essentially an attitude to life. Using a variety of techniques – drawn from Neo-Impressionism, and from Edvard Munch – he painted scenes of riot, of mourning, of a modern *femme fatale*. These show little originality. His major work of 1910 began as a triptych that, in the manner of certain works by Balla, showed Work at three times, Dawn, Day and Night. This developed into his great canvas *The City Rises*, which epitomizes the generation of the modern world of the city in the contrast between pygmy men and their mighty engines harnessed for construction (which, in 1910, still included horses).

There is little about *The City Rises*, apart from its vitality and its subject, that would have seemed original to contemporaries. But, soon after that, Boccioni embarked on a series of canvases which he must have left half-finished in his studio when he visited Paris late in 1911. These are works representing 'states of mind', as Apollinaire recorded. In addition to a triptych which showed *The Farewells* of couples at a railway station, and *Those who Go* on the

35 journey and *Those who Stay,* he was painting a café scene that was called *The Laugh.* His preliminary studies show he developed a swirling, abstract rhythm, derived from Munch and Art Nouveau. The final canvases, after the visit to Paris, show the strong
42 influence of Cubism. This is least successful in *The Laugh,* in which the easily recognizable head of the plump woman who is laughing is in jarring contrast with the Cubist angularities into which the rest of the café and her admirers are shattered by her laughter.
44 Of the three *States of Mind, The Farewells* is the best-known and the most integrated invention; what might be a still-life after Braque unfolds under observation to reveal the embracing couples, like Dante's whirl-wind of lovers, among the indifferent machines of the railway station. It is arguably the one great Futurist painting.

The complexity and ambiguity of the problems the Futurist painters set themselves are illustrated by two of Boccioni's other works of 1911. *Simultaneous Visions* and *The Noises of the Street Enter the House* at first look very similar – so similar that they have been persistently confused. Reproductions published in the London *Sketch* for 6 March 1912, at the time of the Futurists' exhibition, leave no doubt about the pictures' identities, yet a more profound ambiguity
43 remains. *The Noises of the Street Enter the House* appears the more straightforward representation of things seen. It is a view from a balcony, and, although influenced by Cubism, contains nothing the woman shown on the balcony might not have seen, not neces-sarily simultaneously. The lost *Simultaneous Visions,* on the other hand, mixed details from a street scene with a still-life of a bedroom washstand; it seems to have been 'the synthesis of what one remembers and what one sees', as Boccioni wrote. The two titles could indeed be changed over.

The Futurists' visit to Paris was a preparation for the exhibition of their works at the Galerie Bernheim-

Jeune in February 1912. Their catalogue preface – 'The Exhibitors to the Public' – has become known as the definitive statement of Futurist painting. The Futurists took care to deny that they were followers or plagiarists of Cubism. The Cubists still 'worship the traditionalism of Poussin, of Ingres, of Corot, aging and petrifying their art with an obstinate attachment to the past. . . . Our object is to determine completely new laws which may deliver painting from the wavering uncertainty in which it lingers. . . . We have proclaimed ourselves to be *the primitives of a completely renovated sensibility*.'

At first, Apollinaire was hostile; later he came round. He admired Marinetti and Boccioni, and was soon writing in their defence. On 29 June 1913 he even published his own Futurist manifesto: 'L'Anti-tradition futuriste'.

Mutual suspicion and hostility between Cubists and Futurists remained. The Futurists did owe a bigger debt than they cared to admit. Ironically, it was a Frenchman and a Cubist who painted two of the best and most notorious Futurist paintings. Marcel Duchamp, brother of Jacques Villon and Raymond Duchamp-Villon, painted at the time of the Futurists' visit to Paris *Sad Young Man in a Train,* a work that might be a direct illustration of one of the examples given in 'Futurist Painting: Technical Manifesto'. He then painted a study of the body in motion, *Nude Descending a Staircase,* which is in every way closer to Futurism than it is to Cubism, and which, when it was shown in New York in 1913, became the most notorious specimen of 'Modern Art' in the world.

The Paris exhibition was the first major showing of Futurist work outside Italy. It was a success and quickly moved first to London, in March 1912, and on to Berlin, Brussels, the Hague, Amsterdam and Munich. One of the most interesting of the Futurists was Gino Severini, whose huge *Pan Pan at the Monico* was a Toulouse-Lautrec subject of dancers at

a cabaret translated in to gaudy splinters of colour. He was given a one-man exhibition the following year at the new Marlborough Gallery in Duke Street, St James's. Futurism – the word, at least – had become both notorious and fashionable.

Until then, Marinetti had favoured Futurist evenings held at theatres to promote the movement. In 1910 and 1911 he had held events at Trieste, Milan, Turin, Naples, Venice, Padua, Ferrara, Mantua, Como and Treviso. But these evenings of outrageous readings from Futurist writings, and even more outrageous insults – even blows – exchanged between Futurists and audience, were most suitable in Italy, where actors and audience shared a language. Internationally the picture exhibition was a more powerful weapon, and the Futurists exploited it. By the outbreak of the war, Futurism had established, in the eyes of the world, that Modernism, in Art, was Extremism. Russolo's art of noises, Marinetti's typographical poems, his 'words-in-freedom', freely scattered across the page, Carrà's collages of newspaper cuttings that were at once incomprehensible abstract pictures and outrageous 'free-word' poems, Boccioni's sculpture built of scraps of junk – these set a precedent. Dada, the movement established in Zurich during the First World War, learned directly from the Futurists. One of the Dadaists later admitted: 'We had swallowed Futurism, bones, feathers and all.'

The war ended Futurism. As believers in war as the world's hygiene, Marinetti, Boccioni and Russolo joined up almost immediately. Of the principal Futurists, only Sant' Elia (a promising architect) and Boccioni were killed (he, ironically, by a fall while exercising a horse); but when Marinetti set out to reform the movement after the war, it had been overtaken by such later forms as Dada and the various movements to total abstraction of which the Constructivist movement was the most important.

Constructivism

In their essay 'On Cubism' of 1912, Gleizes and Metzinger wrote one sentence that was much repeated: 'Let the picture imitate nothing and let it present nakedly its *raison d'être*.' This has been understood as a demand for an abstract art, but it is not certain that it is. There had been, for many years, a wish to remove from art the taint of imitativeness – unoriginality. Even the writer Gustave Flaubert had written in a letter of 1852–53, 'what I should like to write is a book about nothing, a book dependent on nothing external, which would be held together by the strength of its style'.

Much later, in 1935, Picasso explained the relation of his own work to reality when he said: 'I want nothing but emotion to be given off' by the painting. However, he also said: 'There is no abstract art. You must always start with something. Afterwards you can remove all traces of reality.'

The idea of an art that imitated nothing was not easy to crystallize. In the second decade of the twentieth century several versions and systems were developed, and, for all except the abstractions of Wassily Kandinsky, Cubism was a formative influence.

The oldest of the artists to be influenced by Cubism was a Dutchman, Piet Mondrian. He was already thirty-nine when he arrived in Paris in 1911, but although he had been painting for a number of years he was still searching for a new form of art. Soon after his arrival in Paris, he was strongly influenced by

48 Cubism. His canvases of trees and of still-life were representations reduced to bold, simple outlines. But he was already a convert to Theosophy, and because of this he looked for an art that would be transcendental rather than representational. Even before he left Paris he painted works in which the motif was

49 reduced to such simple forms – staccato plus and

minus signs spread across the canvas – as to be almost totally unidentifiable.

Back in Holland during the war, Mondrian became one of a group called De Stijl. The group published a periodical called *De Stijl* and edited by the propagandist of the movement, Theo van Doesburg. From the writings of Mondrian and Van Doesburg, De Stijl emerges as standing for a unification of the visual arts, and as utopian in its ambition.

Mondrian said in 1919: 'The truly modern artist is aware of abstraction in an emotion of beauty; he is conscious of the fact that the emotion of beauty is cosmic, universal. . . . The new plastic idea cannot, therefore, take the form of a natural or concrete representation, although the latter does always indicate the universal to a degree, or at least conceals it within. This new plastic idea will ignore the particulars of appearance, that is to say, natural form and colour. On the contrary, it should find its expression in the abstraction of form and colour, that is to say, in the straight line and the clearly defined primary colour. . . .

'We find that in nature all relations are dominated by a single primordial relation, which is defined by the opposition of two extremes. Abstract plasticism represents this primordial relation in a precise manner by means of the two positions which form the right angle. This positional relation is the most balanced of all, since it expresses in a perfect harmony the relation between two extremes, and contains all other relations.'

Mondrian saw painting as a model or exemplar of universal harmony or true beauty, and believed that as man developed so he would replace painting by a total environment in which he could live in harmony. De Stijl concerned itself as much with architecture and design as it did with painting and sculpture. And because he believed that his verticals and horizontals did in fact express a perfect harmony and contain all

Piet Mondrian. *Pier and Ocean,* 1914. Charcoal and ink, $21\frac{7}{8} \times 26$ (55.5 × 66). Collection Harry Holtzman, Lyme, Conn.

other relations, when, in 1925, he saw Van Doesburg's compositions including diagonals, he denounced them as personal and subjective, and left the movement.

De Stijl was one of the most influential of the movements of modern art; it was paralleled by the art that accompanied the Russian Revolution of 1917.

The Modern Movement in Russian art was a function of Russia's own historic development from medieval feudalism to nineteenth-century capitalism to revolution within a single lifetime. Russian painting of the eighteenth and early nineteenth centuries had been dependent on the values and achievement of Western European painting. But in the later nine-

teenth century, Russian society and Russian artists began to rediscover a native strength. It can be no coincidence that one of the first great patrons of the second half of the century, Savva Mamontov, was a railway tycoon, or that the artists he patronized rediscovered the values and achievements of medieval native Russian art. Other merchants travelled west and continued to patronize Western painters; but the works they brought back to Moscow were of the most modern. Ivan Morozov bought the paintings of Monet, Cézanne and Gauguin. Sergei Shchukin, another Moscow merchant, was among the boldest collectors of his day. From 1906 to 1914, he visited Paris constantly and bought, from their studios, many works by Matisse and Picasso.

The railroad took the Russians to the West not only to see but to be seen. In 1906, Sergei Diaghilev was the organizer of a Russian section at the Salon d'Automne. It was an exhibition that began with medieval icons and ended with the work of the Moscow avant-garde.

The most talented of the young Russian painters represented at the Salon d'Automne of 1906 were Mikhail Larionov and Natalia Goncharova. Both were born in 1881, the same year as Picasso. They met as students in Moscow and soon became leaders of the avant-garde there. They were equally influenced by 55 the advanced art of the West and the primitivism of Russian icons and folk art. They were inspired by 58, 59 Cubism and the Futurist manifestos; and when, in 1913, Larionov issued a manifesto for a new style he called Rayonnism, it had a distinctly Futurist ring: 'We declare the genius of our days to be: trousers, jackets, shoes, tramways, buses, aeroplanes, railways, magnificent ships. . . . We deny that individuality has any value in a work of art. . . . Hail nationalism! – we go hand in hand with house-painters. . . . Here begins the true freeing of art: a life which proceeds only according to the laws of painting as an independent entity.'

Kasimir Malevich. Backcloth design for *Victory over the Sun*, 1913. Pencil, gouache on paper. Theatrical Museum, Leningrad.

But in 1914 Larionov and Goncharova left Russia to join Diaghilev as designers for his ballet. They never lived again in Russia or contributed to the vital years that followed.

The achievements of the next years were largely those of two rivals, Kasimir Malevich and Vladimir Tatlin. Malevich, the son of a foreman in a sugar factory in Kiev, was largely self-educated. He studied art at the Kiev School of Art, but was twenty-seven before he came to Moscow in 1905, soon to be discovered by Larionov's circle. Between 1909 and 1914, Malevich developed rapidly. From a kind of proto-Cubism, recalling the work of Léger as much as that of Picasso, he passed through a sequence of phases that led him, in 1913, to a type of fragmented collage (anticipating the Dada images of Kurt Schwitters as much as those of Picasso) that he called 'nonsense realism'. These were brilliantly witty, even surreal images, but he quickly moved beyond them –

54, 56

49

almost inadvertently, it might seem – when he was the designer for Kruchenikh's Futurist opera *Victory over the Sun (Pobeda nad Solntsem)* of 1913. The costumes were witty Cubist-Futurist concepts, not quite as outrageous as those Picasso created a few years later for the ballet *Parade*; but it was one of the backcloths that was significant for Malevich. This was simply a square divided into black and white triangles. From this image, Malevich claimed, he moved on immediately to purely abstract paintings of which the first was a black square on a white canvas. He had begun the art he called 'Suprematism'.

It was soon after this that Vladimir Tatlin began his own equally original road. Tatlin was seven years younger than Malevich, having been born in 1885. He ran away to sea when he was eighteen and began to study art only after his first voyage. He moved to Moscow in 1910, and, after only a year as a student, began to exhibit with the circle round Larionov. Influenced at first by Larionov and Goncharova, in 1913 he quarrelled with them and travelled west, first to Berlin and then to Paris.

He visited Picasso and asked to become a kind of apprentice. Picasso did not agree, and so Tatlin returned to Moscow. But in Picasso's studio he had seen the unconventional collages and reliefs that Picasso had made from scraps of cardboard, string and other junk; inspired by these, Tatlin made some of the most revolutionary works of modern art. They were totally non-representational constructions from junk, the most ingenious being designed to span the corner of a room. These were the first works to be called 'constructions'.

Malevich and Tatlin were brought together in two avant-garde exhibitions in 1915. At the first, called 'The Futurist Exhibition: Tramway V', held in Petrograd in February, Tatlin showed reliefs, Malevich his Cubo-Futurist collages of two years earlier. Many works by other artists followed comparable

styles, and the entire exhibition could indeed be seen as the first Futurist exhibition in Russia. But it was in the following December, at '0.10. The Last Futurist Painting Exhibition', that a crisis arose. Malevich wanted to exhibit his completely abstract Suprematist compositions. Tatlin was furious and called them amateur. Eventually their works were hung in separate rooms. With this exhibition, the avant-garde was established in Russia.

The October Revolution of 1917 created the moment for which the avant-garde was ready. The artists accepted that a revolutionary art was a necessary complement to the political and social revolutions, and threw themselves into the struggle. They organized demonstrations and decorations. In the words of the poet Mayakovsky, they set out to make the streets their brushes and the square their palette. An enthusiasm for revolution, for a reconstruction that would be Futurist as much as Bolshevik, gripped the artists.

But as the chaos that immediately followed the Revolution gave way to the beginnings of a new order and a new bureaucracy, the enthusiastic co-operation of those early days dissolved as the different artists looked for positions of power in the new structures. In 1918 a Department of Fine Arts (IZO) was established by the first Commissar of Education, Anatoly Lunacharsky, and he made a number of appointments from the artists of the avant-garde.

Among the many innovations made by IZO, the most significant was the amalgamation, in 1918, of the Moscow College of Painting, Sculpture and Architecture with the Stroganov School of Applied Art into the Higher Technical-Artistic Studios, known as Vkhutemas. Among those who had studios there were Malevich, Tatlin, Kandinsky and Antoine Pevsner. The Institute of Artistic Culture (Inkhuk) delegated the creation of a teaching programme to Kandinsky, previously a member of the *Blaue Reiter* group in

Munich, the creator of the only form of abstract art not directly influenced by Cubism, and, at fifty-two, Inkhuk's senior member.

Kandinsky's programme (published in 1920) was, in effect his theory of art. He proposed that studies should be in two parts, of the 'Theory of separate branches of art' and of the 'Combination of the separate arts to create a monumental art'. Kandinsky's vision was of a new and profound relation between art and society, but the relation was essentially a religious one (like Mondrian, he was a Theosophist). He believed the artist was the man with a loftier spiritual vision than his fellow men; and abstract art was the purer means of communicating this vision. The purpose of artistic training was to provide an Art Dictionary of conscious line and form for each medium. For example, colours were to be studied both individually and in combinations, and 'these studies are to be co-ordinated with medical, physiological and occult knowledge'. With this knowledge, the artist would be able to attack the second part of the programme, the work of monumental art that could produce quite specific and controlled responses ('ecstasy') in its audience.

Kandinsky's programme was voted down by Inkhuk. It was put into practice only after he left Russia in 1922 for Walter Gropius' Bauhaus in Weimar.

Of the younger artists, Malevich was perhaps the most in sympathy with Kandinsky's theories, but he was too independent to work under Kandinsky or indeed anyone else. Invited by the director of the Vitebsk School of Art, Marc Chagall, to teach there, Malevich took advantage of Chagall's temporary absence in Moscow to declare himself Director and rename the school Unovis, the College of the New Art.

As early as 1916, when he announced his art of Suprematism (which led him from a black square on a white canvas in 1913 to a white square on a white canvas in 1918), Malevich had claimed: 'I have de-

stroyed the ring of the horizon and escaped from the circle of things . . . To reproduce beloved objects and little corners of nature is just like a thief being enraptured by his legs in irons.' The Futurists 'took an enormous step forward: they gave up meat [i.e. the nude] and glorified the machine'; but unfortunately this only substituted one kind of copying for another. 'The forms of Suprematism, the new realism in painting, are already proof of the construction of forms from nothing, discovered by Intuitive Reason.' Unlike Futurism, unlike Cubism, said Malevich, 'our world of art has become new, non-objective, pure'.

Like Mondrian, like Kandinsky, Malevich distrusted representational art because he distrusted the world it represented, the world of the senses. However, in the brief time he was director of Unovis at Vitebsk he gallantly insisted that Suprematism was utilitarian.

He wrote in a manifesto of 1920, on 'The Question of Imitative Art': 'Every form is the result of energy moving along the path of an economic principle. Hence stem man's rights and politics. . . . Freedom of action is not action independent, separate and outside the community, for it is an economic, i.e. completely prosaic principle. . . . The general philosophical path of these trends leads to the disintegration of things, to the non-objective and to Suprematism, as a new real utilitarian body and to the spiritual world of phenomena. . . . We are going to work on new creative constructions in life. . . .

'Three cheers for the overthrow of the old world of art.

'Three cheers for the new world of things.

'Three cheers for the common all-Russian auditorium for construction.

'Three cheers for the Red leaders of contemporary life and the Red creative work of new art.'

But two years later, on 12 February 1922, he was writing to a group of Dutch artists to complain that

his compatriots had 'failed to comprehend the importance of the painter or of any art worker for human culture'. This was true even of those who called themselves Constructivists.

Malevich's faith was in a spiritual art. The battle was won, temporarily, by the Constructivist, objectivist factions. These were working in Moscow, at Vkhutemas, and were themselves divided. The faction closest to Malevich centred round two sculptors, Antoine Pevsner and his brother Naum Gabo, who issued a 'Realistic Manifesto' in Moscow on 5 August 1920. In it they condemned Cubism and Futurism and called for an Art 'erected on the real laws of Life'. They continued: 'The plumb-line in our hand, eyes as precise as a ruler, in a spirit as taut as a compass . . . we construct our work as the universe constructs its own, as an engineer constructs his bridges, as a mathematician his formula of the orbits.'

How different this ideal was from that of Malevich can be seen more clearly in Gabo's later explanation (1937). 'I do not hesitate to affirm that the perception of space is a primary natural sense. . . . Our task is to bring it closer to our consciousness; so that the sensation of space will become for us a more elementary and everyday emotion, the same as the sensation of light or the sensation of sound.' He continued: 'The shapes we are creating are not abstract, they are absolute. . . . The emotional force of an absolute shape is unique and not replaceable by any other means. . . . Shapes exult and shapes depress, they elate and make desperate. . . . The constructive mind which enables us to draw on this inexhaustible source of expression and to dedicate it to the service of sculpture.'

This is an art of real materials in real space, such as Tatlin had called for; but it still is an art for the mental faculties, an art concerned with expression and emotion. Tatlin himself saw art as the product of a decadent society, and took as his slogan 'Art into Life'. He remained, as he had been for half-a-dozen years, the

Vladimir Tatlin. *Monument to the Third International,*
1919–20. Wood, iron and glass. Remnants of this maquette
are stored in the Russian Museum, Leningrad.

opponent of Malevich. He became more and more a designer of things. He designed, in the hard days of 1918–19, a stove to consume the minimum of fuel and give the maximum heat. He designed a worker's outfit of clothes. He spent years attempting to perfect a flying machine, *Letatlin,* with wings like a falcon's. His greatest conception was his design for a *Monument to the Third International,* commissioned in 1919 to be erected in the centre of Moscow. A model exhibited at the Eighth Congress of Soviets in December 1920 showed a strange skeletal structure, intended to be twice the height of the Empire State Building in New York and tilted on a diagonal axis, as if the Eiffel Tower had been reconstructed as a rocket-launching pad. It contained within its spiral framework three geometrical solids, halls for meetings, which were to revolve once a year, once a month and once a day respectively. On cloudy nights it would project slogans on to the sky above Moscow.

The clash of ideologies that divided the Constructivists and other artists of the Revolution was never settled within Russia. As the central government became established, the initiative of these revolutionaries was put down. Instead an art that the people could understand became more favoured, until, at last, the *Small Soviet Encyclopedia* (3rd edn, 1960) described Constructivism as 'a formalistic tendency in bourgeois art, which developed after the First World War 1914–18. Anti-humanistic by nature, hostile to realism, Constructivism appeared as the expression of the deepest decline of bourgeois culture in the period of the general crisis of capitalism.'

Kandinsky, Pevsner and Gabo left Russia in 1922 and 1923 and never returned. Kandinsky accepted a post at the Bauhaus, a school which in some ways resembled the Moscow Vkhutemas, and in which the uselessness of traditional Fine Art and the mere utilitarianism of machine-produced objects were to be transcended by good functional design.

Of the Russians bringing Constructivism to the West, the most important was one of the youngest, El Lissitzky, born in 1890. He was both architect and graphic designer. His paintings called *Prouns* owed a good deal to Malevich, and might be seen either as abstracts or as designs for a new architecture. They were also ingenious and witty. This is the secret of his brilliant graphic designs, which combine geometrical shape, photographic images and typography in a revolutionary way. His street poster of 1919–20 called on the People to *Beat the Whites with the Red Wedge,* and the design showed a red triangle penetrating a white circle.

Lissitzky, too left Russia in 1922, and went first to Berlin where he organized an exhibition of 'Modern Russian Abstraction' at the Van Diemen gallery. His influence on De Stijl, on the teaching of the Bauhaus, and on Western abstract art in general, was important. He ended his days in Russia as a designer of exhibitions and posters.

The principles of Constructivism were codified in Western Europe by the pedagogic programme taught at the Bauhaus between 1923 and 1928 by the Hungarian László Moholy-Nagy. In an eclectic programme that owed much to Kandinsky but more to Lissitzky, Moholy-Nagy eschewed the mysticism of Mondrian, Kandinsky and Malevich. Abstract art, he said 'projects a desirable future order'. Art, he said, 'is the senses' grindstone, sharpening the eyes, the mind and the feelings'. It 'creates new types of spatial relationships, new inventions of forms, new visual laws – basic and simple – as the visual counterpart to a more purposeful, cooperative human society'.

Chronology

1904 Picasso settles at the Bateau Lavoir, meets Salmon.

1905 Picasso meets Apollinaire. Fauves exhibit at the Salon d'Automne.

1905/06 Picasso meets Gertrude and Leo Stein. Matisse exhibits *Le Bonheur de Vivre,* bought by Leo Stein.

1906/07 Winter, Picasso begins *Les Demoiselles d'Avignon.*

1907 Braque sells all six Fauve canvases he exhibits at the Salon des Indépendants. Kahnweiler signs a contract for his entire production. Apollinaire takes Braque to Picasso's studio. Braque begins *Nude* in response to the *Demoiselles.*

1908 November, Braque exhibits new landscapes at Kahnweiler's, and Louis Vauxcelles writes of his 'cubes'.

1909 On 20 February, 'Foundation and First Manifesto of Futurism', by F. T. Marinetti, published in French on the front page of *Le Figaro.* Picasso spends summer at Horta de Ebro in Catalonia; Braque spends the summer at La Roche-Guyon. Returning to Paris in autumn they find their work is becoming increasingly similar.

1910 Artists influenced by Picasso and Braque exhibit Cubist works at Salon d'Automne. On 11 February, 'Manifesto of Futurist Painters'; on 11 April, 'Technical Manifesto of Futurist Painting'. Futurist evenings in Italy.

1911 Cubist rooms at the Salon des Indépendants and the Salon d'Automne establish Cubism as a major influence. Picasso and Braque do not exhibit. Juan Gris paints his first Cubist works. The Futurists Boccioni and Carrà visit Paris, and Severini, who lives there, introduces them to the Cubist painters, including Picasso. Mondrian arrives in Paris.

1912 Gleizes and Metzinger publish 'Du Cubisme'.

1913 Apollinaire publishes *Les Peintres cubistes.* Marcel Duchamp's *Nude Descending a Staircase.* In Moscow, Larionov and Goncharova publish Rayonnist and Futurist manifesto. Tatlin visits Berlin and Paris; seeks to become Picasso's apprentice.

1914 Marinetti lectures in Moscow and Petrograd. Mondrian returns to Amsterdam.

1915 Malevich and Tatlin exhibit in Petrograd.

1916 Boccioni dies after a fall from a horse.

1917/18 After the initial revolutionary chaos, the arts are organized by the Department of Fine Arts (IZO). In 1918, Malevich exhibits his *White on White* canvases. Rod-

chenko exhibits *Black on Black* canvases. Kandinsky appointed member of art *kollegia* in IZO. Death of Apollinaire, 9 November.

1919 IZO gives Tatlin commission to design *Monument to the Third International*. Rodchenko is made co-director of Industrial Art Faculty in Moscow. Malevich usurps Chagall's position as head of School of Art in Vitebsk.

1919 Gropius appointed director of the Bauhaus, Weimar.

1920 Kandinsky presents his programme for the Institute of Artistic Culture in IZO in Moscow, but it is rejected by the Constructivists. Gabo and Pevsner: Realist manifesto.

1921 Kandinsky leaves Russia for the Bauhaus. '5 × 5 = 25', an exhibition of Constructivist works by Rodchenko, Vesnin, Exter, Popova and Stepanova. IZO liquidated.

Further Reading

The first and most impressive study of Cubism remains John Golding's *Cubism: A History and an Analysis 1907–1914,* London, 1959. A different and very useful volume is Edward F. Fry's *Cubism,* London and New York, 1966, which includes a brief history and translations of 48 texts written by those closest to Cubism between 1905 and 1944. Both volumes contain extensive bibliographies. Gleizes and Metzinger's essay *On Cubism* is translated unabridged in *Modern Artists on Art,* edited by R. L. Herbert, New York, 1964. An invaluable collection of Apollinaire's art criticism is *Apollinaire on Art: Essays and Reviews 1902–1918,* London and New York, 1972. An even more idiosyncratic view of the period is given by Gertrude Stein's *Autobiography of Alice B. Toklas.*

On Futurism, Joshua C. Taylor's catalogue for the Museum of Modern Art, *Futurism,* New York, 1961, remains a useful introduction; while R. Carrieri's *Futurism,* Milan, 1963 (in English), provides a great deal of visual material. But Futurism was an art of manifestos, and many of these have been translated and published in *Futurist Manifestos,* edited by Umbro Apollonio, London and New York, 1973.

On Constructivism, Camilla Gray's *The Great Experiment: Russian Art 1863–1922,* London and New York, 1962 (also available in a cheaper edition as *The Russian Experiment in Art, 1863–1922,* London and New York, 1971) is still unique in the field. *The Tradition of Constructivism,* edited by

Stephen Bann, London and New York, 1974, will be invaluable. *El Lissitzky* by Sophie Lissitzky-Küppers, London and New York, 1968, is useful and contains many writings by the artist. On the Dutch abstract artists, H. L. C. Jaffe's *De Stijl,* London and New York, 1970, is authoritative.

List of Illustrations

Measurements are given in inches and centimetres, height first.

12 Georges Braque (1882–1963). *Still-life with Herrings (Still-life with Fish),* c. 1909–11. Oil on canvas, $24\frac{1}{4} \times 29\frac{1}{2}$ (61.5 × 75). Tate Gallery, London. See p. 20.

13 Pablo Picasso (1881–1973). *Still-life with Gourd,* 1909. Oil on canvas, $28\frac{3}{4} \times 23\frac{5}{8}$ (73 × 59). Private collection, Paris.

14 Pablo Picasso (1881–1973). *Ambroise Vollard,* 1909–10. Oil on canvas, $36\frac{1}{4} \times 25\frac{9}{16}$ (93 × 65). Pushkin Museum, Moscow. See p. 21.

15 Pablo Picasso (1881–1973). *Daniel-Henry Kahnweiler,* 1910. Oil on canvas, $39\frac{5}{8} \times 28\frac{5}{8}$ (100 × 73). The Art Institute of Chicago, gift of Mrs Gilbert W. Chapman. See p. 21.

16 Pablo Picasso (1881–1973). *Still-life with Chair Caning,* 1912. Oil and oil-cloth pasted on canvas, $10\frac{5}{8} \times 13\frac{3}{8}$ (27 × 35). Private collection. See p. 26.

17 Georges Braque (1882–1963). *Newspapers and Glass,* 1913. Oil on canvas, $20\frac{7}{8} \times 14\frac{1}{8}$ (53 × 36). Private collection, Zurich.

18 Robert Delaunay (1885–1941). *Simultaneous Windows,* 1911. Oil on canvas, $18 \times 15\frac{3}{4}$ (46 × 40). Collection Jean Cassou, Paris. See p. 28.

19 Robert Delaunay (1885–1941). *The City, No. 2,* 1910. Oil on canvas, 57 × 45 (145 × 115). Musée National d'Art Moderne, Paris. See pp. 22, 28.

20 Fernand Léger (1881–1955). *Contrasts of Forms,* 1913. Oil on canvas, $21\frac{5}{8} \times 18$ (55 × 46). Kunstmuseum, Berne, Collection Hermann Rupf Foundation. See p. 28.

21 Fernand Léger (1881–1955). *Nude Model in Studio,* 1912. Oil on cloth, $37\frac{3}{4} \times 49\frac{1}{4}$ (96 × 125.5). The Solomon R. Guggenheim Museum, New York. See p. 28.

22 Jacques Villon (1875–1963). *Marching Soldiers,* 1913. Oil on canvas, $25\frac{9}{16} \times 36\frac{1}{4}$ (64.8 × 91.5). Galerie Louis Carré, Paris. See p. 28.

23 Juan Gris (1887–1927). *Sunblind,* 1914. Papier collé on canvas, with some heightening in charcoal, $36\frac{1}{4} \times 28\frac{5}{8}$ (92 × 72.5). Tate Gallery, London. See p. 29.

24 Juan Gris (1887–1927). *Still-life with Fruit and Bottle of Water,* 1914. Collage, $36\frac{1}{4} \times 25\frac{1}{2}$ (92 × 65). Rijksmuseum Kröller-Müller, Otterlo. See p. 29.

25 Louis Marcoussis (1883–1941). *Still-life with Chess-board,* 1912. Oil on canvas, $54\frac{3}{4} \times 36\frac{5}{8}$ (139 × 93). Musée National d'Art Moderne, Paris. See p. 28.

26 Giacomo Balla (1871–1958). *Dynamism of a Dog on a Leash,* 1912. Oil on canvas, $35\frac{5}{8} \times 43\frac{1}{4}$ (91 × 110). Albright-Knox Art Gallery, Buffalo, N.Y. Courtesy George F. Goodyear and the Buffalo Fine Art Academy. See p. 36.

27 Giacomo Balla (1871–1958). *Speed of Car + Lights + Noise,* 1913. Oil on canvas, $50\frac{3}{4} \times 34\frac{1}{4}$ (129 × 87). Kunsthaus, Zurich. See p. 37.

28 Giacomo Balla (1871–1958). *Girl Running on a Balcony,* 1912. Oil on canvas, $49\frac{1}{4} \times 49\frac{1}{4}$ (125 × 125). Galleria d'Arte Moderna, Milan. See p. 37.

29 Giacomo Balla (1871–1958). *Rhythm of a Violinist,* 1912. Oil on canvas, $29\frac{1}{2} \times 20\frac{1}{2}$ (75 × 52). Collection Mr and Mrs Eric Estorick, London. See p. 37.

30 Giacomo Balla (1871–1958). *Iridescent Interpenetrations,* 1913. Oil on canvas, $39\frac{3}{8} \times 35\frac{5}{8}$ (100 × 60). Collection H. L. Winston, Birmingham, Ala. See p. 38.

31 Giacomo Balla (1871–1958). *Iridescent Interpenetrations no. 4,* 1913. Oil on canvas mounted on cardboard, $29\frac{7}{8} \times 21\frac{1}{4}$ (76 × 54). Galleria Blu, Milan. See p. 38.

32 Carlo Carrà (1881–1966). *The Swimmers,* 1910. Oil on canvas, $61 \times 41\frac{3}{8}$ (155 × 105). Museum of Art, Carnegie Institute, Pittsburgh, Pa. See p. 38.

33 Carlo Carrà (1881–1966). *Funeral of the Anarchist Galli,* 1911. Oil on canvas, $102\frac{3}{8} \times 73$ (260 × 185). The Museum of Modern Art, New York. See p. 38.

34 Carlo Carrà (1881–1966). *Leaving the Theatre,* 1910/11. Oil on canvas, $35\frac{3}{8} \times 28$ (90 × 70.5). Tate Gallery, London, Collection Mr and Mrs Eric Estorick. See p. 38.

35 Umberto Boccioni (1882–1916). Study for *States of Mind: Those who Stay,* 1911. Oil on canvas, $28 \times 29\frac{7}{8}$ (71 × 76). Civica Galleria d'Arte Moderna, Milan. See p. 42.

36 Luigi Russolo (1885–1947). *Memories of a Night,* 1911. Oil on canvas, 39×39 (99 × 99). Miss Barbara Jane Slifka Collection, New York. See p. 39.

37 Luigi Russolo (1885–1947). *Solidity of Fog,* 1912. Oil on canvas, 39×25 (99 × 63.5). Private collection, Milan. See p. 39.

38 Luigi Russolo (1885–1947). *Music,* 1911. Oil on canvas, $86\frac{5}{8} \times 55\frac{1}{8}$ (220 × 140). Collection Mr and Mrs Eric Estorick, London. See p. 39.

39 Umberto Boccioni (1882–1916). *The City Rises,* 1910. Oil on card, $23\frac{5}{8} \times 14\frac{5}{8}$ (60 × 37). Collection Jesi, Milan.

40 Umberto Boccioni (1882–1916). *The Modern Idol,* 1911. Oil on board, $23\frac{5}{8} \times 10\frac{3}{4}$ (59.7 × 58.4). Collection Mr and Mrs Eric Estorick, London. See p. 41.

41 Luigi Russolo (1885–1947). *Perfume,* 1909–1910. Oil on canvas, 25 × 24 (63.5 × 61). Collection Mr and Mrs Harry Lewis Winston, Birmingham, Mich. See p. 39.

42 Umberto Boccioni (1882–1916). *The Laugh,* 1911. Oil on canvas, $57\frac{1}{8} \times 43\frac{1}{4}$ (145 × 110). The Museum of Modern Art, New York, Gift of Mr and Mrs H. Rothschild. See p. 42.

43 Umberto Boccioni (1882–1916). *The Noises of the Street Invade the House,* 1911. Städt. Galerie, Hanover. See p. 42.

44 Umberto Boccioni (1882–1916). *States of Mind I: The Farewells,* 1911. $27\frac{1}{4} \times 37\frac{3}{4}$ (69 × 96). The Museum of Modern Art, New York, Collection Nelson A. Rockefeller. See p. 42.

45 Carlo Carrà (1881–1966). *Interventionist Demonstration,* 1914. Tempera and collage. Private collection, Milan. See p. 44.

46 Marcel Duchamp (1887–1968). *Sad Young Man in a Train,* 1911. Oil on canvas mounted on board, $39\frac{3}{8} \times 28\frac{3}{4}$ (100 × 73). Collection Mrs Peggy Guggenheim, Venice. See p. 43.

47 Marcel Duchamp (1887–1968). *Nude Descending a Staircase, No. 2,* 1912. Oil on canvas, $57\frac{1}{2} \times 35\frac{1}{16}$ (146 × 89). Philadelphia Museum of Art, The Louise and Walter Arensberg Collection. See p. 43.

48 Piet Mondrian (1872–1944). *Oval Composition (Trees),* 1913. Oil on canvas, $36\frac{5}{8} \times 30\frac{3}{4}$ (93 × 78). Stedelijk Museum, Amsterdam. See p. 45.

49 Piet Mondrian (1872–1944). *Oval Composition,* 1913–14. Oil on canvas, $44\frac{1}{2} \times 33\frac{3}{8}$ (113 × 85). Gemeentemuseum, The Hague, Collection S. B. Slijper, on loan. See p. 45.

50 Piet Mondrian (1872–1944). *Composition in Colour A,* 1917. Oil on canvas, $19\frac{1}{2} \times 17\frac{3}{8}$ (50 × 44). Rijksmuseum Kröller-Müller, Otterlo. See p. 46.

51 Piet Mondrian (1872–1944). *Composition with Red, Yellow and Blue*, 1921. *Oil on canvas*, $15\frac{1}{2} \times 13\frac{3}{4}$ (39 × 35). Gemeentemuseum, The Hague, Collection S. B. Slijper, on loan. See p. 46.

52 Theo van Doesburg (1883–1931). *Pure Painting*, 1920. Oil on canvas, $53\frac{1}{2} \times 34$ (135.8 × 86.5). Musée National d'Art Moderne, Paris. See p. 46.

53 Kasimir Malevich (1878–1935). *Suprematist Composition: Red Square and Black Square*, 1915 or 1914 (?). Oil on canvas, $28 \times 17\frac{3}{4}$ (71 × 45). The Museum of Modern Art, New York. See p. 50.

54 Kasimir Malevich (1878–1935). *The Knife-Grinder*, 1912. Oil on canvas, $31\frac{1}{2} \times 31\frac{1}{2}$ (80 × 80). Yale Art Gallery, New Haven, Conn. See p. 49.

55 Natalia Goncharova (1881–). *The Cyclist*, 1912–13. Oil on canvas, $7\frac{1}{2} \times 41\frac{3}{8}$ (19 × 105). Russian Museum, Leningrad. See p. 48.

56 Kasimir Malevich (1878–1935). *An Englishman in Moscow*, 1914. Oil on canvas, $22\frac{1}{2} \times 34\frac{5}{8}$ (57 × 88). Stedelijk Museum, Amsterdam. See p. 49.

57 Kasimir Malevich (1878–1935). *Yellow, Orange and Green*, c. 1914. Oil on canvas, $14 \times 17\frac{1}{2}$ (35.5 × 44.5). Stedelijk Museum, Amsterdam. See p. 50.

58 Mikhail Larionov (1881–). *Blue Rayonnism*, 1912. Oil on canvas, $25\frac{1}{2} \times 27\frac{1}{2}$ (65 × 69). Private Collection. See p. 48.

59 Mikhail Larionov (1881–). *Portrait of a Woman*, 1911. Musée National d'Art Moderne, Paris. See p. 48.

60 Kasimir Malevich (1878–1935). *Dynamic Suprematism*, 1916. Oil on canvas, $31\frac{1}{2} \times 31\frac{1}{2}$ (80 × 80). Tretyakov Gallery, Moscow. See p. 50.

61 El Lissitzky (1890–1941). *Beat the Whites with the Red Wedge*, 1919. Street poster. See p. 57.

62 El Lissitzky (1890–1941). *Proun 12 E, c.* 1920. Oil on canvas, $22\frac{1}{2} \times 16\frac{5}{8}$ (57.1 × 42.7). Busch Reisinger Museum, Harvard University, Cambridge, Mass. See p. 57.

COVER Pablo Picasso (1881–1973). *The Three Dancers* (detail), 1925. Oil on canvas, $84\frac{3}{4} \times 56$ (215.3 × 142.2). Tate Gallery, London. See p. 27.

4

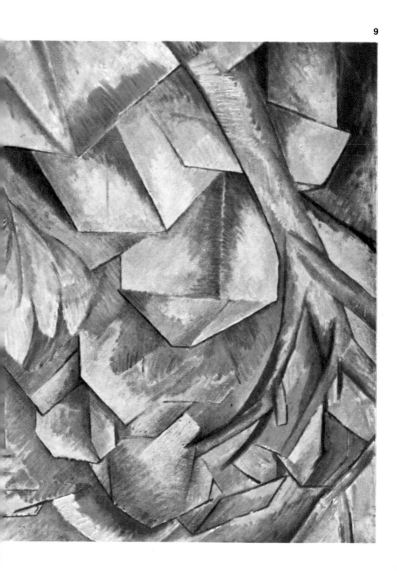

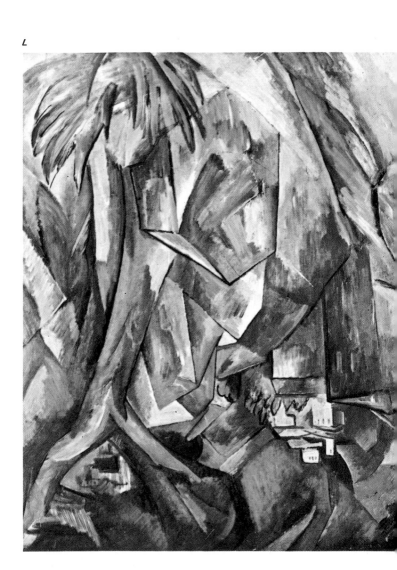

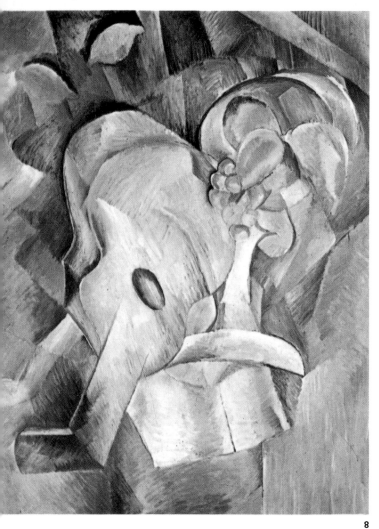

8

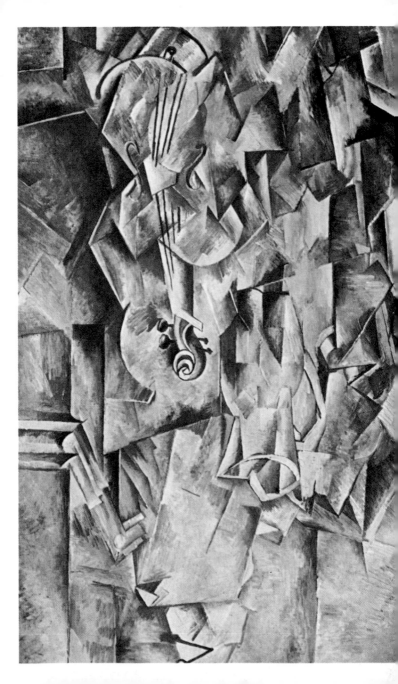

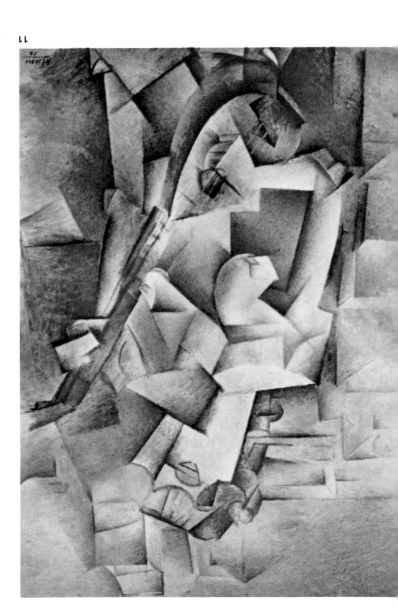

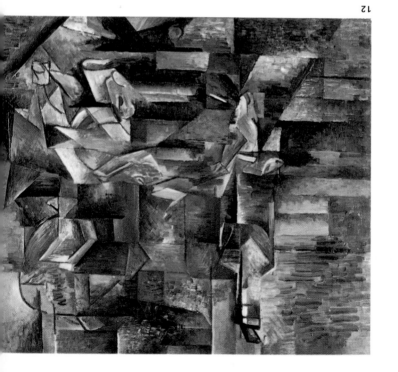

13

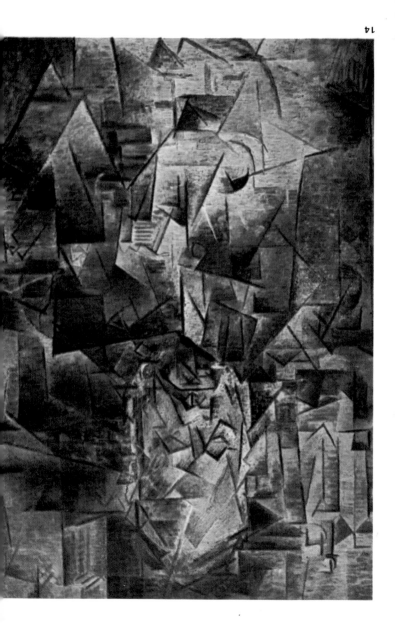

18

20

FLÉGE

24

28

29

30

31

34

35

37 - 38 ▶

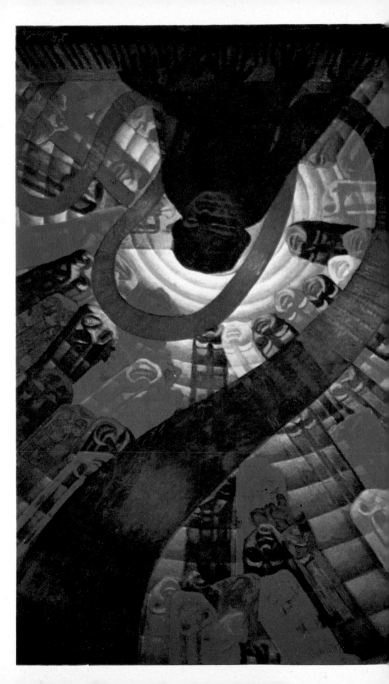

39

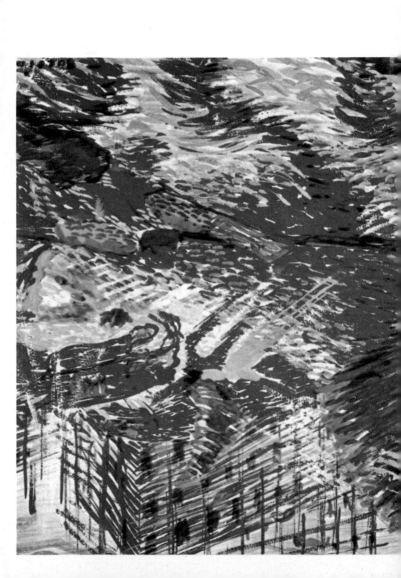

40

41

42

44

45

48

49

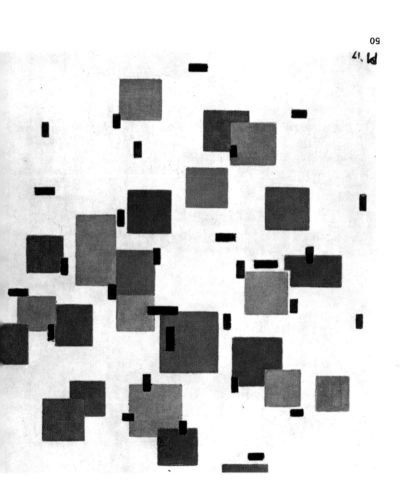

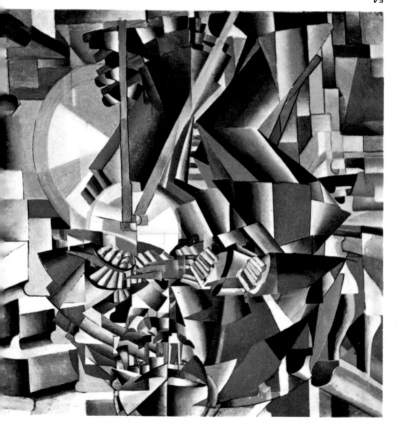

58

59

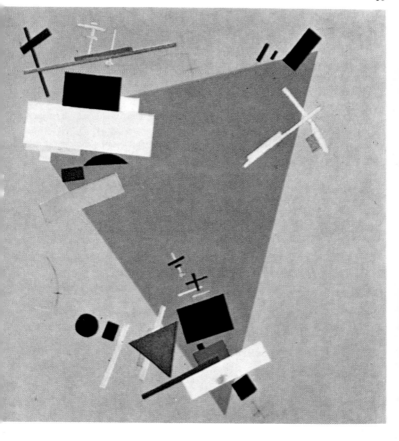